WINTER

With Essays by Donald Hall and Clifton C. Olds

Hood Museum of Art, Dartmouth College

Distributed by University Press of New England

Hanover and London

UNIVERSITY PRESS OF NEW ENGLAND

Brandeis University University of Connecticut University of Rhode Island
Brown University Dartmouth College Tufts University
Clark University University of New Hampshire University of Vermont

Printed in Japan

LIBRARY OF CONGRESS CATALOGING IN PUBLICATION DATA
Main entry under title:
Winter : published on the occasion of the exhibition,
 Winter, February 1 through March 16, 1986, Hood
 Museum of Art, Dartmouth College, Hanover, New
 Hampshire.
 Includes index.
 1. Winter in art—Exhibitions. 2. Art—Exhibitions.
I. Hall, Donald, 1928– . II. Olds, Clifton C.
III. Hood Museum of Art.
N8262.5.W55 1986 760'.074'01423 85–15767
ISBN 0–87451–354–5
ISBN 0–87451–355–3 (pbk.)

This exhibition has been made possible by gifts from the William B.
Jaffe and Evelyn A. Jaffe Hall Endowment Fund; Jane and Raphael
Bernstein, the Bernstein Development Foundation; and Vermont
Castings, Inc.

Cover/jacket illustration: Childe Hassam, *Late Afternoon, New York:
Winter,* 1900, The Brooklyn Museum, Dick S. Ramsay Fund (cat.
no. 47).

CONTENTS

Exhibition Advisory Committee vii

Lenders to the Exhibition ix

Preface *Jacquelynn Baas* xi

WINTER
Donald Hall 1

"A HEARTBREAKING BEAUTY"
Images of Winter in Western and Asian Art
Clifton C. Olds 15

CATALOGUE OF THE EXHIBITION 47

Photo Credits 135

Index of Artists 137

EXHIBITION ADVISORY COMMITTEE

JOHN JACOBUS
Leon E. Williams Professor of Art History,
Dartmouth College

JIM M. JORDAN
Chairman, Department of Art History,
Dartmouth College

ROBERT L. MCGRATH
Professor of Art History, Dartmouth College

CLIFTON C. OLDS
Edith Cleves Barry Professor of the History of Art, Bowdoin College

JOHN WILMERDING
Deputy Director, National Gallery of Art

MARSHALL WU
Curator of Asian Art, University of Michigan Museum of Art

FUMIO YOSHIMURA
Assistant Professor of Art, Dartmouth College

LENDERS TO THE EXHIBITION

ADDISON GALLERY OF AMERICAN ART, *Phillips Academy, Andover, Massachusetts*

ANONYMOUS LENDER

ART GALLERY OF ONTARIO, *Ontario, Canada*

THE ART MUSEUM, PRINCETON UNIVERSITY, *Princeton, New Jersey*

MR. AND MRS. A. L. AYDELOTT

WILLIAM NATHANIEL BANKS

MR. AND MRS. JOHN I. H. BAUR

BOWDOIN COLLEGE MUSEUM OF ART, *Brunswick, Maine*

THE BROOKLYN MUSEUM, *Brooklyn, New York*

STERLING AND FRANCINE CLARK ART INSTITUTE, *Williamstown, Massachusetts*

WILLIAM S. CLARK

THE CORCORAN GALLERY OF ART, *Washington, D.C.*

THE CURRIER GALLERY OF ART, *Manchester, New Hampshire*

THE DETROIT INSTITUTE OF ARTS, *Detroit, Michigan*

HENRY MELVILLE FULLER

GILMAN PAPER COMPANY, *New York, New York*

KURT AND MILLIE GITTER

CAROL AND JAMES GOODFRIEND

THE ARMAND HAMMER FOUNDATION, *Los Angeles, California*

MR. AND MRS. PETER HEYDON

THE KEMPE COLLECTION

MR. AND MRS. NORMAN KRAEFT

RAYMOND J. LEARSY

LITTLETON PUBLIC LIBRARY, *Littleton, New Hampshire*

FREDERICK AND JAN MAYER

MEAD ART MUSEUM, *Amherst College, Amherst, Massachusetts*

THE METROPOLITAN MUSEUM OF ART, *New York, New York*

THE MINNEAPOLIS INSTITUTE OF ARTS, *Minneapolis, Minnesota*

MONTCLAIR ART MUSEUM, *Montclair, New Jersey*

MONTGOMERY MUSEUM OF FINE ARTS, *Montgomery, Alabama*

THE PIERPONT MORGAN LIBRARY, *New York, New York*

MUSEUM OF ART, RHODE ISLAND SCHOOL OF DESIGN, *Providence, Rhode Island*

MUSEUM OF FINE ARTS, *Boston, Massachusetts*

MUSEUM OF FINE ARTS, *Springfield, Massachusetts*

THE MUSEUM OF MODERN ART, *New York, New York*

THE MUSEUMS AT STONY BROOK, *Stony Brook, New York*

NATIONAL MUSEUM OF AMERICAN ART, *Smithsonian Institution, Washington, D.C.*

NEW YORK STATE OFFICE OF PARKS, RECREATION AND HISTORIC PRESERVATION, *Bureau of Historic Sites, Olana State Historic Site, Taconic Region*

THE PENNSYLVANIA ACADEMY OF THE FINE ARTS, *Philadelphia, Pennsylvania*

JOHN AND MABLE RINGLING MUSEUM OF ART, *Sarasota, Florida*

SAN DIEGO MUSEUM OF ART, *San Diego, California*

SHELBURNE MUSEUM, *Shelburne, Vermont*

SMITH COLLEGE MUSEUM OF ART, *Northampton, Massachusetts*

RALPH STEINER

TERRA MUSEUM OF AMERICAN ART, *Evanston, Illinois*

UNIVERSITY ART MUSEUM, *University of California, Berkeley, California*

THE UNIVERSITY OF MICHIGAN MUSEUM OF ART, *Ann Arbor, Michigan*

KING W. VIDOR TRUST

MR. AND MRS. WAN-GO H. C. WENG

WHITNEY MUSEUM OF AMERICAN ART, *New York, New York*

YALE CENTER FOR BRITISH ART, *New Haven, Connecticut*

PREFACE

For this first loan exhibition in the new museum at Dartmouth College, the staff of the Hood Museum of Art wanted a subject that would be regionally appropriate yet would have universal appeal. An exhibition of art representing the winter season promised to meet the criteria in a delightfully open way. Both the exhibition and the catalogue do convey something special about our location in northern New England. At the same time, as the catalogue essays suggest in a variety of ways, these works of art touch us at archetypal levels, reminding us of the continuity of human experience that artistic expression can make available, regardless of cultural boundaries.

We are immensely grateful to Clifton Olds of Bowdoin College (and a member of the Dartmouth class of 1957), and to Donald Hall, who is the Poet Laureate of New Hampshire, for enriching this catalogue with their essays. The concept of the exhibition owes much to Wolf Kahn, Dartmouth artist-in-residence during the winter of 1984. Suggestions for works to be included were provided by an exhibition committee consisting of Barbara MacAdam and Malcolm Cochran of the Hood staff; John Jacobus, Jim Jordan, and Robert McGrath of the Art History Department, Dartmouth College; Fumio Yoshimura of the Visual Studies Department at Dartmouth; and, as outside advisors, Clifton Olds, John Wilmerding, and Marshall Wu.

The lenders to this exhibition, listed on pages ix–x of this catalogue, have our lasting gratitude. Some of these individuals were also helpful in suggesting additional possibilities for the exhibition. We gratefully acknowledge the advice of Judith Barter of the Mead Art Museum, Amherst College; John I. H. Baur; Henry Melville Fuller; Pierre Apraxine of the Gilman Paper Company collection; Raymond J. Learsy; William S. Clark; Wan-go H. C. Weng; Peter Heydon; Mr. and Mrs. Norman Kraeft; Laura Luckey, Assistant Director of the Shelburne Museum; John Plummer, Curator of Medieval and Renaissance Manuscripts at the Pierpont Morgan Library; Patricia Loiko and Trevor Fair-

brother of the Museum of Fine Arts, Boston; and Michael Goodison of the Smith College Museum of Art. Others who helped locate works or assisted in various ways also deserve mention. We are indebted to Stephen Addiss, Grace Borgenicht, Walter Burke, William A. Coles, Wanda M. Corn, Pamela Hoyle, and Donald Kelley for their kind assistance.

Museum staff members who were involved in this project are the hardest to thank. They have given so generously and tirelessly of themselves, in quite individual ways, that it would require another "preface" to acknowledge their full contribution. Barbara MacAdam of the Hood curatorial staff was the primary organizer of this exhibition, which would not have come to pass without her intelligence, diligence, and tact. In addition, I wish to publicly thank our museum registrar, Hazel Burrows, and her assistant, Karin Rothwell; administrative assistant Hilary Ragle and her assistant, Susan Moody; and photographer Jeffrey Nintzel. Appreciative thanks are due Malcolm Cochran, for designing the exhibition, and his skilled and imaginative colleagues, Evelyn Marcus and Robert Raiselis.

The staff of Dartmouth's Sherman Art Library provided essential research support, and we thank Jeffrey Horrell, Marilyn Gasser, Jean Hill, and Claudia Yatsevitch for their inexhaustible kindness and patience. David Robbins contributed valuable editorial assistance. Thomas McFarland, director of the University Press of New England, along with Mary Crittendon of the UPNE staff, provided essential advice and support throughout the project. The final form of this catalogue reflects the talents of Joyce Kachergis.

Finally, we would like to thank Jane and Raphael Bernstein, Vermont Castings, Inc., and especially Evelyn A. Jaffe Hall. Their generous patronage has made this exhibition possible.

JACQUELYNN BAAS
Director, Hood Museum of Art

WINTER

WINTER

Donald Hall

In New Hampshire we know ourselves by winter—in snow, in cold, in darkness. For some of us the first true snow begins it; for others winter begins with the first bruising assault of zero weather; there is yet another sort, light-lovers, for whom winter begins with dark's onset in mid-August. If we wake as we ought to at 5:30, we begin waking in darkness; and dawn turns throaty with the ululations of photophiliacs, noctophobics, some of whom are fanatical enough to begin lamentation late in the month of June—when dawn arrives at 4:32 A.M. and yesterday it arrived at 4:31:30. On June 22 my wife exchanges postcards of commiseration with a fellow in Michigan who is another amorist of light. Fortunately this mountain has an upside as well as a downside. When in January daylight lasts half a minute longer every day, Jane's faint green leaves take color on, she leans South toward Kearsarge and the low, brief but lengthening pale winter sun; an observer can spy the faint buds that will burst into snowdrops in April, daffodils in April, tulips in May . . .

Some of us, on the other hand, are darkness-lovers. We do not *dislike* the early and late daylight of June, whippoorwill's graytime, but we cherish the gradually increasing dark of November, which we wrap around ourselves in the prosperous warmth of woodstove, oil, electric blanket, storm window, and insulation. We are partly tuber, partly bear. Inside our warmth we fold ourselves in the dark and the cold—around us, outside us, safely away from us; we tuck ourselves up in the long sleep and comfort of cold's opposite, warming ourselves by thought of the cold; lighting ourselves by darkness's idea. Or we are Persephone gone underground again, cozy in the amenities of Hell. Sheltered between stove and electric light, we hollow islands of safety within the cold and dark. As light grows less each day our fur grows thicker. By December 22 we are cozy as a cat hunkered under a Glenwood.

Often October has shown one snow-flurry, sometimes even September. For that matter, it once snowed in New Hampshire every month of

the year. In 1816, it snowed and froze in June, in July, in August—the Poverty Year, season of continuous winter when farmers planted over and over again, over and over again ripped out frozen shoots of corn and pumpkin. A volcanic eruption in the South Seas two years earlier did it—though at the time our preachers thought the source more local and divine-wrath explicit.

Winter starts in November, whatever the calendar says, with gray of granite, with russet and brown of used leaves. In November stillness our stonewalls wait, attentive, and gaunt revenant trunks of maple and oak settle down for winter's stasis, that annually mimics and presages death for each of us and for the planet. November's palette, Braque's analytic cubism, static and squared with fieldstones, interrupts itself briefly with the bright-flapped caps of deer hunters and their orange jackets. Always it is modified by the black-green fir, enduring, hinting at permanence. Serious snow begins one November afternoon. Gradually Mt. Kearsarge, south of us, disappears into white gauzy cloud, vanishing mountain, weather-sign for all of us to its north. For one hundred and eighty years the people of this house have looked south at dawn's light and again at sunset to tell the coming weather, reliable in 1802 when the first builder put in the south windows, reliable still. When Kearsarge disappears, the storm comes closer. Birds gather at the feeder, squabbling, gobbling their weight. When they are full they look for shelter, and we do the same, or at least we bring wood from the shed to stack beside the old Glenwoods and the new Jøtul.

Every year the first snow sets us dreaming. By March it will only bring the grumps, but November snow is revenance, a dreamy restitution of childhood or even infancy. Tighten the door and settle a cloth snake against the breeze from the door's bottom; make sure the storms are firmly shut; add logs to the stove and widen the draft. Sit in a chair looking south into blue twilight that arrives earlier every day—as the sky flakes and densens, as the first clear flakes float past the porch's wood to light on dirt of the driveway and on brown frozen grass or dry stalks of the flower border. They seem tentative and awkward at first, then in a hastening host a whole brief army falls, white militia para-trooping out of the close sky over various textures making them one. Snow is white and gray, part and whole, infinitely various yet infinitely repetitious, soft and hard, frozen and melting, a creaking underfoot and a soundlessness . . . But first of all it is the reversion of many into one.

It is substance, almost the idea of substance, that turns grass, driveway, hayfield, old garden, log pile, Saab, watering trough, collapsed barn, and stone wall *into the one white*.

We finish early in November the task of preparing the house for snow—tacking poly over the low clapboards, raking leaves against the foundations as high as we can rake them. When the first real snow arrives, no dusting half inch but a solid foot, we complete the insulation, for it is snow that keeps us warm. After a neighbor's four-wheel-drive pickup, plow bolted in front, swoops clean our U-shaped driveway, and after we dig out the mailbox for Bert's rural delivery, it is time to heap the snow over leaves and against poly, around the house, on all sides of the house, against the granite foundation stones. Arctic winds halt before this white guard. When bright noon melts inches of snow away from the house, reflecting heat from the snowy clapboard, it leaves cracks of cold air for us to fill when new snow falls all winter long.

But November, although it begins winter, is only winter's approach, with little snow, and with cold that announces itself only to increase. The calendar's winter begins at the solstice, Advent's event: the child's birth who rises from winter to die and rise again in spring. November is autumn's burial and the smoke of victims sacrificed, is thanks for harvest and magic as we go into ourselves like maples for winter's bear-sleep. We make transition by way of feast and anticipatory snow, toward the long, white, hard hundred days of the true winter of our annual death. We wait for December to feel the *cold*, I mean COLD, like thirty-five degrees below zero Fahrenheit. Seldom does it stay *cold*, or COLD, for longer than a week, but we are ready now for snow.

The first *big* snow accumulates one night. Kearsarge may disappear at noon, and darkness start early. In teatime twilight, big flakes slowly, as if hesitant, reel past the empty trees like small white leaves, star-shaped and infrequent. By bedtime, driveway and lawn turn shaggy with the first cover. It is good to go to bed early in winter, and tonight as we sleep our dreams take punctuation from the thudding of snowplows as they roll and bluster all night up and down Route Four, shaking the house yet comforting our sleep: Someone takes care, the solitary captains in their great snowships breasting through vast whiteness, fountaining it sideways into gutter drifts. If we stir as they thump past, we watch revolving yellow lights flash through our windows and reflect on the ceiling. We roll over and fall back into protected sleep. In a houseful

of cats we sleep not alone, for the snowplows that reassure us frighten our animals like thunder or riflefire; they crawl between our warm bodies under warmer electric blankets.

When we become aware, by the plows' repeated patrols, that the first deep snow accumulates; when the first intense and almost unbreakable sleep finishes and we enter the frangible second-half of the night's house, I pull myself out of bed at two or three in the morning to inspect the true oncoming of winter's work. I walk through the dark house from one vantage to another—parlor window that looks west toward pond, kitchen from which I look toward Kearsarge, dining room that gives on the north, and if I twist, back to the slope of Ragged Mountain rising east above us. The night's flaking air breaks black sky into white flecks, silent and pervasive, shuttering the day's vista. This snow fills the air and the eyes, the way on spring nights peepers fill the ears. Everywhere I look, limited by snow-limits, cold dewy whiteness takes everything into itself. Beside the covered woodshed, side by side, I see the shapes of two small cars rounded and smooth like enormous loaves of dead-white bread. Where the woodpile waits for final stacking in the shed, a round mound rises with irregular sticks jagging out of it. Up on the hill the great cowbarn labors under a two-foot layer of snow, its unpainted vertical boards a dark upright shadow in all the whiteness, like the hemlocks above it on Ragged's hill. Although snowplows keep Route Four passable, they do not yet scrape to the macadam: In the darkness the highway is as white as the hayfields on either side. Down the road white cottage disappears against white field, green shutters a patch of vacancy in the whiteness. In the stillness of two A.M., in a silent unlit moment with no plows thudding, I regard a landscape reverted to other years by the same snow—and I might be my great-grandfather gazing from the same windows in 1885. Or it might be his mother's eyes I gaze from, born on a Wilmot hill in 1789. Or maybe I look, centuries earlier, from the eyes of a Penacook wintering over the Pond. If I squint a little I cannot see that this depression is a road.

But now the snowplow's thunder signals itself and I watch the revolving yellow light reflect upward into white prodigious air, and hear the great bruising barge roar and rumble past the house, 1985 and grateful, as a steel prow swooshes high waves of whiteness up and over the gutter almost to the front of the house, and buries the mailbox.

One year the first great snow came Christmas Eve after the family

had struggled to bed. When we lit the tree in the morning, the day was thick and dark past the windows, and as we opened our presents the snow deepened in yard and hayfield outside, and on Christmas Day, all day, the great plows of state and town kept Route Four clear. Snow stopped at three in the afternoon, and when Forrest rolled in to plow the driveway in the early blue twilight, Jane heaped slices of turkey between homemade bread to comfort him in his cab as he drove over the countryside digging people out.

The next morning was cold, thirty below, cold enough to notice. January is the coldest month, in fact, although many would argue for February. Usually our cold is dry, and it does not penetrate so much as damp cold. December of 1975, our first full winter here, I tried starting the Plymouth one morning with normal confidence in the old six, and without cold-weather precautions; I flooded it. When I looked at the thermometer I was astonished to find it minus seventeen degrees, for my face and forehead had not warned me that it was *cold*. I had lived in Michigan where the winters were damp, and Ann Arbor's occasional zero felt harsher than New Hampshire's common twenty below. Later that winter we did not complain of the mildness. In January of 1976 morning after morning was thirty below; one morning on the porch the thermometer read thirty-eight degrees under—a temperature we did not equal again until 1984. My grandmother had just died at ninety-seven, and she had spent most of her late winters going south to Connecticut. The house had grown unaccustomed to winter, the old heavy wooden storm windows broken, no central heat, and no insulation. Jane and I had never lived without central heat. Now we had a parlor Glenwood stove for heating, two kerosene burners in the kitchen, and on occasion an electric oven with the door left open. This twelve-room house, in January of 1976, dwindled to a one-room house, with a kitchen sometimes habitable. Working at the dining room table, twenty feet from the living room's Glenwood, I felt chilly. At the time, we were too excited or triumphant to complain. We were camping out; we were earning our stripes. The next summer we added aluminum combination storms and screens together with some insulation; we added two more small woodstoves, one for each study so that we could each work despite the winter. My grandparents survived with only two woodstoves because they bustled around all day; in our work we sat on our duffs and required extra stoves. When February came we learned we had passed

our initiation, for it had been the coldest January since New Hampshire started keeping records more than a hundred years earlier. In all my grandmother's ninety-seven Januarys she had not known so cold a month.

My grandfather worked all day without any heat except for the bodies of his cows. When he sat at morning and evening between two great steaming black-and-white Holstein hulks, pulling the pale thin tonnage of blue milk from their cud-chewing bodies, he was warm. I can remember him, on my winter visits to the farm as a boy, scurrying into the house for a warm-up between his other daily chores, rubbing his hands together, opening the drafts of one of the woodstoves and looming over it for a moment. Early and late, he moved among cold sheds and unheated barns. In the cowbarn, he fed the cattle hay, grain, and ensilage, and provided his horse Riley with oats and hay and water. He let the Holsteins loose to wander stiff-legged to the old cement watering trough next to the milk room, from which he first removed a layer of ice. Their pink muzzles dipped one by one into the near-freezing water. And he fed the sheep in sheepbarn and sheepyard. From the sheep's trough he dipped out water for the hens, who lived next door to the sheep, and carried feed for his hens from the grainshed beside the cowbarn.

He would start these chores early, most days of deep winter, rising at 4:30, perhaps three hours before the sun, to do half the daily chores of feeding and watering, of milking and readying milk for the trucker, because the special daily chores of winter were the year's hardest. The pains of minus twenty were exacerbated by pains of hard labor. To chop wood for next year's stove the farmer stalked with his axe into his woodlot after chores and breakfast, and often marched far enough so that he carried with him his bread and butter, meat and pie, and thermos of coffee for dinner. Setting out with a great axe, usually working alone, the farmer chopped the tree down, trimmed branches, cut the trunk into four-foot sections, and stacked it. Later he would hitch oxen to the sledge and fetch the cordwood downhill for cutting in the barnyard to stove-length pieces, and for splitting. Maybe ten cord of a winter, for the house—more for the sugaring in March.

In January he harvested another winter crop—the crop that people forget, when they think of the needs of an old farm—which was the harvest of ice, cut in great oblongs two or three feet thick from Eagle

Pond, ox-sledded up to the icehouse in back of the cowbarn's watering trough, packed against warm weather six months hence. Each winter the farmer waited for a cold stretch, auguring through the pond ice to check its thickness. Then he cut checkerboard squares with his ice saws. He kept himself heavily mittened not only against cold and wind rattling over the open desert lake, but also against the inevitable clasp of near-frozen water. A crew of them—neighbors cooperated to fetch ice—sawed and grappled, lifted and hauled, hard work and cold work. In the icehouse they stacked layers of ice, thickly insulated with sawdust, to last from the earliest warmth of April through hot spells of June and the long summer haydays of July and August through autumn with its Indian summer until the ice froze again. In the hot months my grandfather brought one chunk a day downhill from the icehouse, great square balanced with ice-tongs on his shoulder, to the toolshed behind the kitchen where my grandmother kept her ice-box, drip drip. Most ice went to cool the milk, hot from the udders of Holsteins, so that it would not spoil overnight in the hot summer. July and August, I was amazed every time we dug down through the wet sawdust in the cool shade of the icehouse to find cold winter again—packed silvery slab of Eagle Pond preserved against summer, just as we hayed to preserve for the winter-cattle summer's hay. On the hottest days when we returned sweaty from haying, my grandfather cracked off a little triangle of ice for me to suck on. Every January when he dug down in the icehouse to bury his crop of new ice, he found old ice underneath it; after all, you never wanted to find yourself all out; some years, there might be hot days even in November, when you would require a touch of ice. One long hot autumn, he found at the bottom of the ice shed, further than he ever remembered digging, a small coffin-shaped remnant from times past, ice that might have been five years old, he told me; maybe older . . .

And my grandfather told me how, in the State of Maine especially, in the old days, clipper ships loaded up ice and sawdust, at the end of winter, and sailed this cargo—transient mineral, annual and reproducible reverse-coal tonnage—down the East Coast to unload its cool for the South that never otherwise saw a piece of ice: ice by the ton for coastal cities like Charleston, South Carolina. Sometimes they sailed all the way to the West Indies with their perishable silvery cargo: Maine ice for the juleps of Charleston, northern January cooling Jamaica's rum.

By tradition the hard snow and heavy cold of January take a vacation for the eldritch out-of-time phenomenon of January thaw. Sometimes the January thaw comes in February, sometimes it never arrives at all, and on the rarest occasions it starts early and lasts all winter . . . Mostly the January thaw lives up to its name. Some strange day, after a week when we dress in the black of twenty below, we notice that we do not back up to the fire as we change our clothing. Extraordinary. Or at midday we pick up the mail in our shirtsleeves, balmy at forty-two degrees. (It is commonplace to observe that a temperature which felt Arctic late in August feels tropical in mid-January.) Icicles drip, snow slides off the south roof in midday sun, and mud season takes over the driveway. Snow melts deeply away from clapboard and poly. Or the January thaw comes with warm rain. ("If this was snow we'd have twelve feet. . . .") And if warm rain pours for three January days, as I have known it to do, Ragged's melt floods our driveway, snow vanishes from all hayfields, and water drowns the black ice of Eagle Pond. Our small universe confuses itself with false spring. Bears wake perplexed and wander looking for deer-corpses or compost heaps, thinking that it's time to get on with it. I remember fetching the newspaper one morning at six o'clock (I pick up the *Globe* outside a store nearby which does not open for customers, slug-a-beds, until eight o'clock) on the third day of a warm rain. Chugging through deep mud in my outboard Nissan, I pulled up at the wet porch to see a huge white cat rooting about in perennials beside the walk, a white pussycat with black spots . . . Oh, no . . . Therefore I remained in the front seat, quietly reading the paper, careful not to make a startling sound or otherwise appear rude—until the skunk wandered away.

Until we replaced rotten sills three years ago, a family of skunks lived in our rootcellar every winter. We never *saw* them, but we found their scat; we found the holes by which they entered and exited; we confirmed their presence by another sense. In the spring they sometimes quarreled, possibly over the correct time and place for love, and we could hear them snapping at each other, and, alas, we discovered that skunks used on each other their special skunk-equipment: Once a year in February or March we threw our windows wide open. On one occasion, Ann Arbor friends visited in March, dear friends notable for the immaculateness of their house in a culture of unspotted houses. When we brought them home with their skis from the airport, and opened the

door, we discovered that our rootcellar family had suffered a domestic disagreement; therefore we opened all downstairs windows, although it was of course fifteen below. As we prepared to take our friends upstairs to their bedroom, where the air would be purer, we opened the doorway upstairs to discover a dead rat on the carpet, courtesy of a guardian cat. Welcome to the country.

January thaw is dazzling, but it is a moment's respite. If this were January in England we would soon expect snowdrops; here we know enough to expect replacement battalions of snow's troopers following on coldness that freezes the melt, covering it with foot upon foot of furry whiteness and moon-coldness. We return to the satisfactions of winter, maybe even to the deliverance and delirium of a full moon.

In New Hampshire the full moon is remarkable all year long, because we suffer relatively little from garbage-air and even less from background light. The great cloudless night of the full moon is werewolf time, glory of silver-pale hauntedness whenever it happens—but in winter it is most beautiful. I set the internal alarm, maybe three or four nights in a row, and wander, self-made ghost, through pale rooms in the pewter light while the moon magnifies itself in bright hayfields and reflects upward, a sun from middle earth, onto shadowy low ceilings. High sailing above, higher than it has a right to, bigger, the February full moon, huge disc of cold, rides and slides among tatters of cloud. My breathing speeds, my pulse quickens; for half an hour I wander, pulled like a tide through the still house in the salty half-light, more asleep than awake, asleep not in house or nightshirt in 1985 but in moon, moon, moon . . . What old animal awakens and stretches inside the marrow of the bones? What howls? What circles, sniffing for prey?

It's no winter without an ice storm. When Robert Frost gazed at bent-over birch trees and tried to think that boys had bent them playing, he knew better: "Ice storms do that." They do that, and a lot more, trimming disease and weakness out of the tree—the old tree's friend, as pneumonia used to be the old man's. Some of us provide life-support systems for our precious shrubs, boarding them over against the ice; for the ice-storm takes the young or unlucky branch or birch as well as the rotten or feeble. One February morning we look out our windows over yards and fields littered with kindling, small twigs and great branches. We look out at a world turned into one diamond, ten thousand karats in the line of sight, twice as many facets. What a dazzle of spinning re-

fracted light, spider-webs of cold brilliance attacking our eyeballs! All winter we wear sunglasses to drive, more than we do in summer, and never so much as after an ice-storm with its painful glaze reflecting from maple and birch, granite boulder and stonewall, turning electric wires into bright silver filaments. The snow itself takes on a crust of ice, like the finish of a clay pot, that carries our weight and sends us swooping and sliding. It is worth your life to go for the mail. Until sand and salt redeem the highway, Route Four is quiet; we cancel the appointment with the dentist, stay home, and marvel at the altered universe, knowing that mid-day sun will strip ice from tree and roof and restore our ordinary white winter world.

Another inescapable attribute of winter, increasing in the years of postwar affluence, is the Ski People, cold counterpart of the Summer folks who have filled New Hampshire's Julys and Augusts ever since the railroad came in the 1840s. Now the roads north from Boston are as dense on a February Friday as they are on a July; and late Sunday afternoon Interstate 93 backs up from the tollbooth. On twenty thousand Toyotas pairs of skis ride north and south every weekend. At Christmas vacation and school holidays every hotel room fills all week with families of flatlanders. They wait in line at the tows, resplendent in the costumes of money, booted and coiffed in bright petrochemical armor. They ride, they swoop, they fall, they drink whiskey . . . and the bonesetter takes no holiday, on a New Hampshire February weekend, and the renter of crutches earns time and a half. Now that cross-country rivals downhill, the ski people grow older and more various; tourism, which rivals the yardsale as major North Country industry, brings Massachusetts and New York money for the thin purses of the cold land. And by the fashionable areas—much of Vermont, and the Waterville Valley in New Hampshire's White Mountains—restaurants and boutiques, cute-shops and quiche-cafés buzz like winter's blackflies.

The snowmachine breaks trails for cross-country, and it is also the countryman's ski outfit. Few natives ski, though some have always done, and in our attic there are wide heavy wooden skis from the time of the Great War on which my mother and her sisters traipsed all winter, largely doing cross-country but perfectly willing to slide down a hill. Oldtimers remember the horse as ski-tow, pulling adventurers up hill.

The motorcycle roar of snowmachines, from a distance indistinguish-

able from chainsaws, interrupts the down-quiet of mid-week evenings, as kids roar along disused railroad tracks and over the surface of frozen lakes. Mostly kids. The older folks, men mostly, park their bobhouses on thick ice of winter lakes, saw holes in the ice, light a fire, warm themselves with a pint of whiskey, and fish for the wormless perch of winter. Like deerhunting in November, of course, this fishing is not mere sport; it fills the freezers of ten thousand shacks, trailers, and extended farmhouses. On Eagle Pond just west of us we count six or a dozen bobhouses each winter, laboriously translated by pickup and pushed or slipped across the ice to a lucky spot. Most springs it seems one fisherman waits too late. How many little houses, some with tin stoves flaking away, raise a freshwater Davy Jones's condominium on the bottom of Eagle Pond?

After the labor of cordwood and ice in the old days, in March as the winter ended, followed the great chore of maple sugaring. It still arrives, though without so much labor. Usually it comes in March, one stretch, but on occasion the conditions for sap turn right for two weeks in February, go wrong for twenty days, then right again—a split season of sugaring. Right conditions are warm days when the snow melts followed by cold nights when it freezes. Nowadays people suction sap from the sugarbush with miles of plastic tubing. In the old time, you pounded the spigot into the tree—several of them in a good-sized three-hundred-year-old maple—and hung a bucket from each for the sap to drip into. My grandfather trudged from tree to tree every day, wearing a wooden yoke across his shoulders; long pails hung from the ends of it, narrow on top and wide on bottom, for collecting sap from each bucket. He emptied these yoke-pails into a great receptacle sledged by an ox—oxen were especially useful in the winter, slow but unbothered by snow—and when he filled this great sledge-kettle his ox pulled it to a funnel and pipe whence the sap flowed downhill to a storage tank behind the saphouse.

Gathering sap was a third of the work, or maybe a quarter. There was cordwood to cut, and to burn under the trays boiling the sap down. Someone had to tend the fire day and night, and to watch and test the sap on its delicate journey to syrup. In 1913 my grandfather corked five hundred gallons at a dollar a gallon, big money in 1913, with the help of his father-in-law Ben Keneston, cousin Freeman, and Ansel the hired

man. When we remember that it takes about forty gallons of sap, boiled down, to make one gallon of syrup, we begin to assess the labor required.

But the sweetness of the task was not only the cash crop. With honey from the beehive next to the barn and the hollyhocks, my grandfather and grandmother grew and produced their own sweetening. With the cash from syrup—sometimes from wool and baby lambs—they bought land and paid taxes. Often their tax was little or nothing, for in the old days many farmers paid their taxes by doing road work—scraping and rolling the dirt roads, filling in with hardpan, and in winter rolling down the snow on the road to make it fit for the runners of sleighs, taking on a mile of Wilmot's Grafton Turnpike.

March was always the month for blizzards. Still is. It is the time when we all tell ourselves: *We've had enough of winter.* Old folks come back from Florida and Hilton Head; younger ones, fed up, head off for a week where the weather performs like May or June in New Hampshire. Every morning the *Globe* measures a word from Florida: *baseball . . .* In New Hampshire, tantalizing melt is overwhelmed with four feet of snow, drifts to twelve feet . . . We comfort each other, when we use the form of complaint for our boasting, that, even if we lost the old outhouse yesterday, or the '53 Buick that the chickens use for summer roosting, what comes quick in March goes quick in March, and three or four days from now it'll melt to reveal the lost Atlantis of the family barnyard. Of course three or four days later, we find another four feet.

Blizzards happen in March, like the great one of '88, that the old people still bragged about in the 1940s. My Connecticut grandfather and my New Hampshire one, who shared little, shared the blizzard of '88: a great watershed for bragging, or for telling lies about. And in the 1980s I still ask old people what they remember that *their* old people told them about '88, much as the '88ers themselves asked their oldtimers about the Poverty Year of 1816. Great weather makes great stories. Paul Fenton told me a story he heard as a boy, not about '88 but just about "the big snows we used to have, back in the old days." It seems that a bunch went out after a heavy snow, dragging the roads with the help of oxen so that people could use their sleighs and sledges, when one of the oxen slipped and got stuck, couldn't move at all; got a hoof caught in something . . . Well, they dug down, dug around, trying to free the ox's

hoof, and what do you know . . . That ox had stuck its foot into a chimney!

Now the blue snow of 1933 is *not* a lie. I am sure of it, because of the way Ansel Powers tells me about it, because his wife Edna confirms it, because Les Ford from Potter Place, who has never been known to collaborate on a story, remembers it just as well and tells the same stories. It may be hard to believe: *but it was blue.* You stuck a shovel in it, and it was *blue*, blue as that sky, blue as a bachelor's button. It fell in April, a late snow, and it fell fast. Les remembers that he'd been to a dance at Danbury, and when he went to bed at midnight the sky was clear and full of stars; when he woke up in the morning, there was three feet of blue snow. The snowplows were disassembled for summer; the road agent had to start up the old dozer and go up and down the road with it, to clear a way for the Model Ts—and a few shiny Model As. Nobody *saw* it snow except Sam Duby, the same blacksmith who made the first snowplows in Andover. He woke up at two or three in the morning and had to do something, you know; well, the outhouse was across the road in the barn and he came out on the porch and it was snowing to beat the band and he just dropped a load right there . . . He's the only one that saw it snow; the rest of us went to bed under stars, woke up to the sun shining in three feet of *blue snow*.

In *The Voyage of the Beagle* Charles Darwin wrote about finding red snow, *Protococcus nivalis*, on the Peuquenes ridge in Chile in 1835. "A little rubbed on paper gives it a faint rose tinge mingled with a little brick-red." When he examined it later, Darwin found "microscopical plants." As far as I know, no one took our blue snow into a laboratory.

Of course it snows in April, every year, most often white, but you cannot call it winter any more. Snow sticks around, in the north shade, most years until early in May, but it is ragged and dirty stuff, and we overlook it as we gaze in hopeful amazement at this year's crop of daffodils. Every year the earlier daffodils fill with snow, bright yellow spilling out white crystals, outraged optimism overcome by fact. And the worst storm I have driven through, after ten New Hampshire winters, occurred a few years back on the ninth day of May.

But annual aberration aside, March is the end of winter, and the transition to spring is April's melt. One year not long ago we had an open winter, with very little snow, *no* snow we all said; we exaggerated a little

for we had an inch here and an inch there. The winter was not only dry but mild, which was a good thing, for an open winter with cold weather destroys flowers and bushes and even trees, since snow is our great insulator. As it was, in our open winter we suffered one cold patch—twenty below for a week—and in the spring that followed, and in the summer, we discovered winter-kill: A few rose-bushes and old lilacs, plants and bulbs that had survived for decades, didn't make it that year. When spring came without a melt, when mild days softened with buttery air and the protected daffodils rose blowing yellow trumpets, we felt uneasy; all of us knew:—Lacking the pains of winter, we did not deserve the rapture and the respite of spring.

Our annual melt is the wild, messy, glorious loosening of everything tight. It is gravity's ecstasy as water seeks its own level on every level, and the noise of water running fills day and night. Down Ragged Mountain the streams rush, cutting through ice and snow, peeling away winter's cold layers. Rush, trickle, rush. Busy water moves all day and all night, never tired, cutting away the corrupt detritus of winter. Fingers of bare earth extend down hillsides. South sides of trees extend bare patches, further every day. Root-patterned rivulets melting gather down-hill to form brief streams. Dirt roads slog, driveways turn swamps, cars smithereen transmissions. Rural delivery, which survives ten thousand blizzards, sticks in the mud of April.

Then it dries. Last snow melts. Trees bud green. Soft air turns. Who can believe in winter now?

All of us. We know that winter has only retreated, waiting. When the bear comes out of its winter sleep, winter itself goes into hibernation, sleeping off the balmy months of peeper-sing until the red leaf wakes it again and the white season returns with the New Hampshire by which we know ourselves.

"A HEARTBREAKING BEAUTY"

Images of Winter in Western and Asian Art

Clifton C. Olds

Almost by definition, art trades in ideals, and in attempting to express them, the artist often shapes a world of unnatural perfection. But the foil to our idealism is the human condition as nature defines and tests it, and here the artist must confront not the ideal but the inevitable. Change, the passage of time, the cruelty or bounty of nature, our own mortality: these are certainties that artists often have expressed in visual metaphors derived from the appearance and character of the four seasons. This exhibition is dedicated to winter, a season that provides a rich source of imagery both glorious and ominous, a condition of nature that promises much and threatens much. It is a subject colored by the persistence of cultural archetypes, by specific iconographic traditions, by the human response to the moods of nature, and by the interaction of these factors. This essay will not attempt to distinguish these elements in any systematic fashion but will focus upon the extraordinary variety and complexity of the theme.

> I, singularly moved
> To love the lovely that are not beloved,
> Of all the Seasons, most
> Love Winter . . .
>
> *Coventry Patmore (1823–1895)*[1]

There are no snows in Utopia; Homer describes the Elysian Fields as a place "where no snow falls, no strong winds blow and there is never any rain"; and St. Ambrose describes the Christian Paradise as free of

[1]Coventry Patmore, "Winter," published in *The Collected Poems of Coventry Patmore* (Oxford, 1949), p. 354.

clouds, storms, cold, and hail.[2] Western art and literature usually depict Eden as warm and green, and the paintings of Jan van Eyck, Albrecht Dürer, and other masters of the Renaissance suggest that Paradise Regained will be equally vernal. It is not surprising, then, given the mind's fondness for symmetry, that artists have found winter to be a natural metaphor for death and despair, reminding us of man's precarious position on the earth. Spring is hope; winter is reality. It is with good reason that we speak of facts as being "hard" and "cold," for those wintry adjectives suggest both the crystalline purity of truth and the bitter certainty of death.

Yet the image of winter in the arts is not without elements of hope. No man can think constantly of his death, as Petrarch observed; and those artists for whom winter has been a subject have often relieved the gloom of their compositions with images of warmth and revelry, or with hints of natural or spiritual resurrection. From the January feasts and snowball fights of late medieval manuscript illuminations to the exuberant choreography of Frederick Ashton's *Les Patineurs* (*The Skaters*), art has gratefully celebrated the lighthearted pastimes of a season that requires such relief. In consequence, the image of winter has acquired a peculiar ambivalence, a split personality that mirrors the sharpest contrasts of our lives: love and hate, hope and despair, revelry and melancholy. There is something eminently appropriate in the occasional appearance of the two-faced Janus at winter feast scenes in medieval art, for while his forward-and-backward-looking head is a perfect symbol of the passage of time and an apt allusion to the threshold of the year, Janus also suggests the dual nature of the season, a time when life and death stand in close association.

To be sure, the formal ambiguities of winter—its stark beauty and powerful sterility—have not attracted artists of every generation. In the West, it was only with the advent of the Renaissance, and then only in those northern regions where snow and ice lend their distinctive beauty to the landscape, that artists began to see winter as more than just a transition, an interlude of natural dormancy between one growing season and another. But as an inescapable reality rather than a thing of

[2]Homer's description of the Elysian Fields is found in the fourth book of the *Odyssey*, trans. J. W. Mackail (Oxford, 1932), p. 82. St. Ambrose describes Paradise in his *De bono mortis*, 12:53, published in *Seven Exegetical Works*, trans. Michael P. McHugh (Washington, D.C., 1972), p. 108.

beauty, winter readily finds its way into the imagery of cultures for whom art is didactic and encyclopedic rather than esoteric and selective. In agrarian societies for whom the cycle of the seasons is central to the issues of life and death, the interrelationship of Time, Nature, and God provides a major focus of religion and the arts that serve religion. And since the mind expresses its crucial concerns in symbols of the inevitable, it is hardly surprising that many cultures should create images that personify and even deify the seasons. Prehistoric art and the art of nonliterate cultures lie beyond the scope of this exhibition, but in considering "primitive" personifications of the seasons, one could cite the Kachina snow dolls of the Pueblo people, who believe that early in their history, their society was divided into Summer people and Winter people (the association of seasons and human types has its parallel in the Western theory of the Four Temperaments). Winter deities or spirits must have played a major role in many northern cultures for whom natural phenomena were supernaturally generated, and the vestiges of those beliefs still exist: witness the survival of Jack Frost in our own folklore.

However, whereas modern attitudes toward winter may reflect concepts as old as the human mind, the more immediate sources of our seasonal imagery lie in the art of the Hellenistic world and its Christian sequel. Solar worship—central to so many ancient religions and tangential to many modern ones—inevitably involves the worshiper in a concern for the annual weakening and strengthening of the sun. Thus winter takes its place beside the other seasons as a time and condition that must be addressed, propitiated, and, in spite of its negative associations, *celebrated*, for it is in the winter that the sun dies and is born again. Constantine's decision to establish December 25 as the date of Christ's nativity unites the Roman festival of the Unconquered Sun—*sol invictus*—with the solar imagery of the Old and New Testaments and the Christian concept of death and resurrection. The implications for Western art and literature were momentous. In the prayers of Erasmus, the landscapes of Pieter Bruegel the Elder, the poetry of Shakespeare, the cantatas of Bach, the folktales retold by the Brothers Grimm—in every chapter of the history of Western thought one finds winter serving as a metaphor, with or without specifically Christian meaning, for death and rebirth. Although the specific iconography of winter, to which we shall now turn, is as much physical as metaphysical, it is difficult to find

an image of winter in which there is not at least a hint of this elemental association.

> Winter: An old female, in long Mantle,
> furr'd; her Head covered; of a doleful
> Aspect; her left hand wrap'd in her
> Garment, holding it up to her face
> With Tears in her Eyes; a wild Boar,
> and a Flame-pot, by her Side; which
> Shews the cold Season.
>
> *Cesare Ripa,* Iconologia
> *(from the first English translation of 1709)*

Among the earliest references to winter in European art are the calendar illustrations of the Hellenistic world, where the months are represented by appropriate images of human activity, and Roman sculpture and mosaics in which the Four Seasons are personified.[3] Although there is little consistency in the representation of the months, certain physical types and activities appeared frequently enough to establish patterns that have survived into our own era, their persistence partly explained by their appropriateness and, indeed, by their inevitability. In the lands under discussion, winter is *cold*, and so the Roman monuments in which winter months are illustrated often represent December, January, or February as a man or woman wearing heavy robes, cloaked against the winter wind. Such a figure was also the standard personification of the winter season in Roman art, and it continued to serve that function in Western art for the next two millennia. In accordance with Cesare Ripa's prescription, men and women huddled in heavy cloaks represent winter in works as diverse as sixteenth-century Italian bronzes and seventeenth-century English ceramics. Jean-Antoine Houdon's famous statue of a shivering young woman (fig. 1) introduces an erotic factor that is foreign to antique prototypes, but the figure huddled within its inadequate shawl is clearly the direct descendant of the old Roman personification of winter.

[3] The standard source on the iconography of the months and seasons in ancient art is Doro Levi, "The Allegories of the Months in Classical Art," *The Art Bulletin* (1940), 23:251–91. Other sources one may consult for medieval and Renaissance images of the months and seasons include Emile Mâle, *The Gothic Image* (New York, 1972); and Raimond van Marle, *Iconographie de l'art profane au moyen-âge et à la Renaissance* (The Hague, 1931–32).

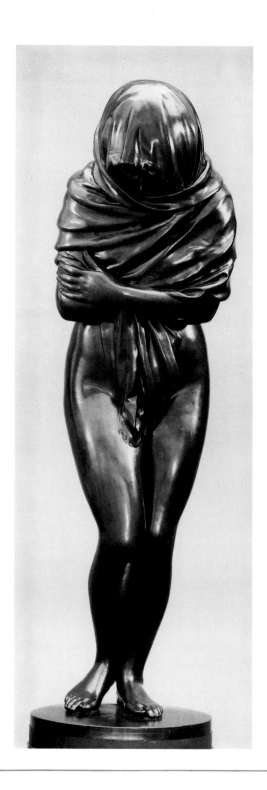

Figure 1. *Jean-Antoine Houdon, French, 1741-1828*
LA FRILEUSE (WINTER), 1787
Bronze, height 57 inches
The Metropolitan Museum of Art, Bequest of Kate Trubbe Davison, 1962 (62.55)

Houdon's work admirably meets the challenge that often faces the painter or sculptor who must attempt to make visible the invisible, in this case the phenomenon of cold. The artists of the Middle Ages often met this challenge by emphasizing the more easily envisioned antidote to cold: heat in the form of fire. Time and again on the pages of medieval manuscripts or the facades of Gothic cathedrals, the month of January or February is represented by a man or woman warming hands or feet at an open fire, an image that finds its most memorable interpretation in the famous February miniature from *Les Très Riches Heures du Duc de Berry* (fig. 2). Here in a painting of ca. 1415, the Franco-Flemish artists known as the Limbourg Brothers show us peasants hoisting their winter garments to warm themselves at the hearth of a rustic farmhouse, while in the bleak winter world beyond its flimsy walls, men cut and deliver the wood that will feed such fires. (We will meet these woodcutters again in the winter landscapes of America.) In this earliest of all extant winterscapes, we have left behind the world of personification and have entered the realm of exemplification, but this, too, has its origins in the art of antiquity. In fact, in most of the ancient calendars the months were represented less often by symbol and metaphor than by examples of seasonal activity. Among the most frequently represented labors of winter were the hunting of wild game and the slaughter of pigs, and scenes showing these two activities would continue to surface throughout the next two millennia of winter imagery. In the *Chronograph of 354 A.D.*, an illustrated Roman manuscript known to us through the medium of a Carolingian copy, February is described as a figure "wrapped in a blue mantle, who sets out to catch the birds of the marshes."[4] This hunter becomes an enduring reference to the winter season. Not only does he appear often in subsequent representations of February, but he also personifies winter in many versions of the Four Seasons, sometimes holding a brace of birds, sometimes a hare. In the so-called Season Sarcophagi of Imperial Roman origin, he loses his winter vestments and takes on the appearance of a nude *genius tempestae*, but he still displays a brace of wild birds (fig. 3).

The association of winter and hunting lives on into the Renaissance, when Pieter Bruegel the Elder places hunters and hunting dogs in the foreground of what is surely the most famous winter landscape in West-

[4]Levi, p. 255.

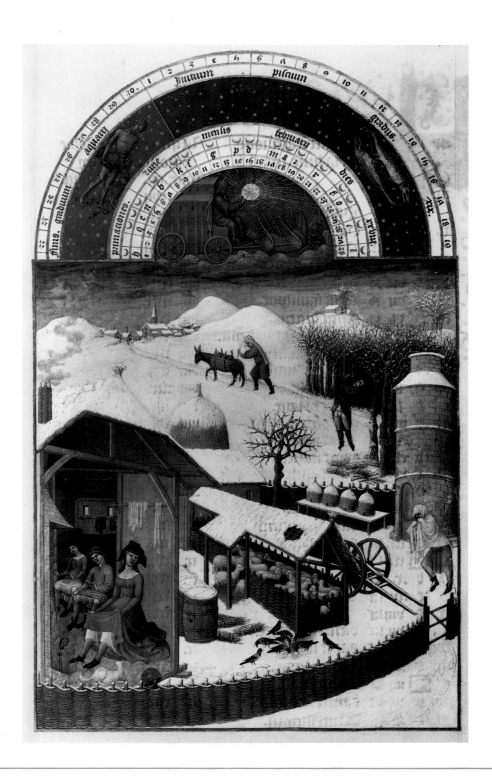

Figure 2. *Limbourg Brothers, Flemish, d. 1416?*
FEBRUARY, from *Les Très Riches Heures du Duc de Berry*, 1413–16

Tempera on parchment, 8⅞ × 5⅜ inches

Musée Condé, Chantilly, France

(In all measurements height precedes width. Dimensions for works of art on paper refer to the size of the plate or image rather than to the support.)

ern art: the painting in Vienna known as *The Return from the Hunt* (fig. 4). Moreover, Bruegel honors another ancient tradition by showing us, in the lower left quadrant of the painting, a country tavern before which peasants tend a roaring fire. The fire itself is a traditional element in winter iconography, as we have seen, and Bruegel employs it here to express the strength of the winter wind. But of even greater interest is the activity around the fire: the peasants are using flaming sheaves of straw to singe the bristles from a recently slaughtered pig. The killing and preparation of pigs for the religious feasts of December and January is an activity that often represents those months in ancient and medieval art; and, in fact, the personification of winter on Roman sarcophagi is sometimes accompanied by a boar (fig. 3). The image persists throughout the Middle Ages, appearing in astronomical calendars of the ninth century, in French sculpture of the thirteenth century (the slaughter of

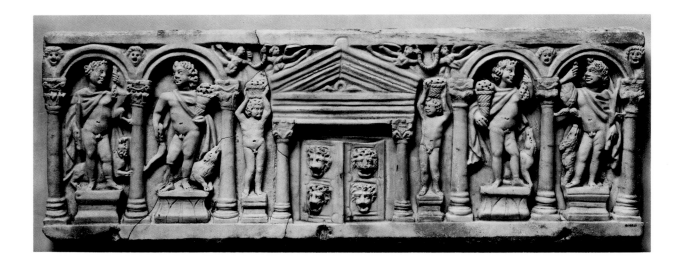

Figure 3. *Roman*
FRONT OF A CHILD'S SEASON SARCOPHAGUS OF THE
ASIATIC COLUMNAR TYPE, 290–300 A.D.
Proconnesian marble, 16¾ × 45½ inches
The Metropolitan Museum of Art, Rogers Fund, 1918 (18.145.51)

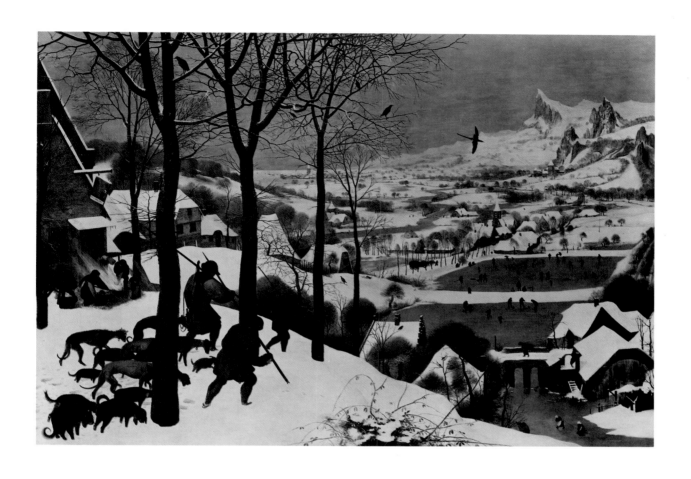

Figure 4. *Pieter Bruegel the Elder, Flemish, 1525/30-1569*
THE RETURN FROM THE HUNT, 1565
Oil on panel, 46 × 63¾ inches
Kunsthistorisches Museum, Vienna

pigs signifies the month of December on the portals of the cathedrals of Paris and Reims), and on the calendar pages of late medieval books of hours. On the pages of *Les Très Riches Heures du Duc de Berry*, the slaughter of pigs and the hunt are in effect combined, for the artists represent the month of December with a scene of hunters bringing down a wild boar (fig. 5). Cesare Ripa included a boar as one of the attributes of winter in the passage cited previously, and as late as the eighteenth century, Francisco Goya recalled this motif in his chilling study of Spanish peasants bracing themselves against a wintry blast and leading a donkey whose burden is a dead boar (fig. 6).

Although Goya's painting shows the theme of hog slaughter near the end of its iconic life, the winter hunt still retains much of its appeal. William Sidney Mount's *Catching Rabbits (Boys Trapping)* (cat. no. 23) is a lighthearted American sequel, and Rockwell Kent's *The Trapper* (cat. no. 57) is an even more obvious descendant of the ancient personification of winter. Whether Kent had any such antecedent in mind is doubtful (the scene is set just outside Kent's own cabin door in the area of Arlington, Vermont), but his painting conjures up a host of old associations—the weary hunters of Bruegel's *Return from the Hunt*, the melancholy of Ripa's description of Winter, and even the elegiac conventions of ancient Greek poetry:

> Naiads and chill cattle-pastures, tell
> to the bees when they come on their
> springtide way, that old Leucippus perished
> when out trapping scampering hares on a winter night . . .
> *Anonymous Greek epitaph (translated by J. W. Mackail)* [5]

Art historians often refer to the seasonal *exempla* of ancient and medieval calendars as "Labors of the Months," but not all the activities chosen to illustrate ancient and medieval calendars are laborious in the strict sense of the word. In fact, as a period of feasting and revelry—the season of the Roman *saturnalia*—winter was often viewed as a respite from labor. This idea persisted long after pagan feasts had given way to Christian festivals. While the hunt and the slaughter of pigs retained

[5] *Select Epigrams from the Greek Anthology*, ed. and trans. J. W. Mackail (London, 1911), p. 266.

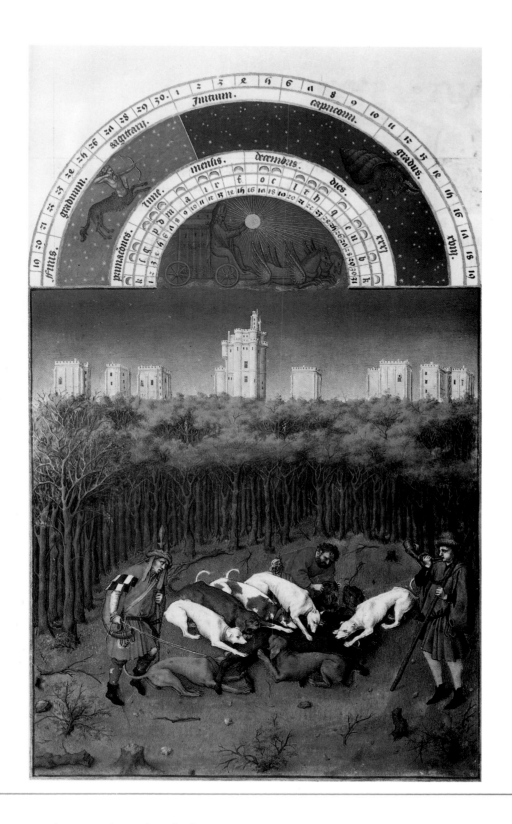

Figure 5. *Limbourg Brothers, Flemish, d. 1416?*
DECEMBER, from *Les Très Riches Heures du Duc de Berry*, 1413–16
Tempera on parchment, 8¾ × 5¼ inches
Musée Condé, Chantilly, France

their significance well beyond the medieval period, the winter feast competed with these images, emerging in the sculpture of the Romanesque and Gothic periods. (The feast represents the month of December at Vézelay, St. Denis, and Chartres; and the month of January at Arezzo, Ferrara, and Amiens.) It is ironic, but not really inappropriate, that these Christian banqueting scenes are sometimes presided over by the pagan deity Janus, the two-faced god of beginnings who, as I have indicated, symbolized the turn of the year and the transition between past and future. Extant Hellenistic calendars do not illustrate this figure, but he appears often enough in ancient calendar texts to suggest that the image was once fairly common in Roman art. Medieval examples undoubtedly reflect these lost prototypes, which may have emphasized the old year as explicitly as did their medieval sequels. On the cathedrals of Chartres, Amiens, and Paris, Janus *bifrons* displays one youthful and one aged face, a didactic reference to past and future with parallels in the writings of Isidore of Seville and other medieval authors for whom pagan allegories were convenient foundations for Christian moralizing.

By the later Middle Ages, however, pagan allegory had given way to contemporary *exempla*. On the pages of the *Très Riches Heures*, for instance, the January feast is presided over by the Duke of Berry himself. As a festive antidote to the grim realities of winter, the banquet theme was persistently attractive, particularly to the artists and patrons of the sixteenth and seventeenth centuries. These later winter feasts bring the tradition full circle in some instances, including among the guests such figures as Bacchus, Comus, and other pagan gods of revelry (cat. no. 16). Even when the subject still retains its Christian meaning, as in the case of Baroque representations of the Epiphany feast, the scene is sometimes a raucous celebration worthy of the ancient *saturnalia*.

But just as Janus "can always see all things from both sides" (to quote the *Chronograph of 354*),[6] so winter pastimes were sometimes seen in a mixed light. A Dutch woodcut of 1498 (cat. no. 13) illustrates the dangers of ice skating by recording the disastrous fall of one Ludwina, a young woman of Schiedam whose tumble resulted in a bedridden life of physical affliction and spiritual ardor (the publication of the *Vita Lidwinae*, for which the print is an illustration, is associated with the proposal of her canonization). Given the medieval mind-set, this acci-

[6] Levi, p. 253.

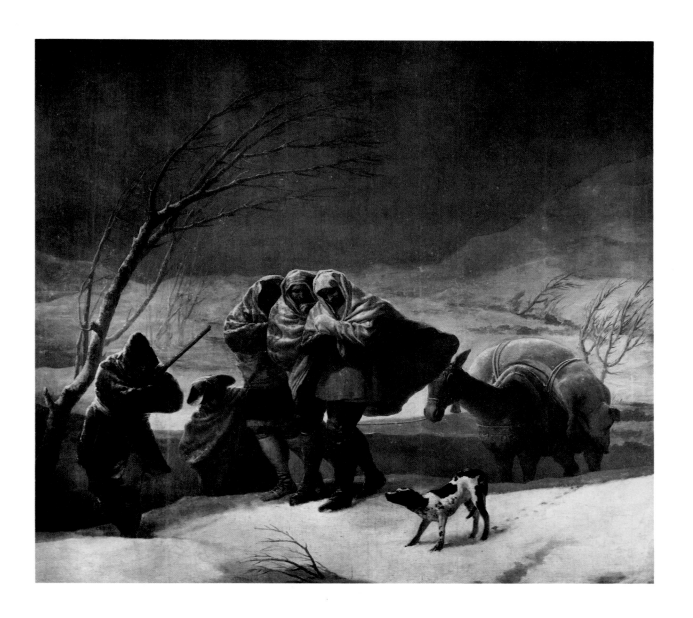

Figure 6. *Francisco Goya, Spanish, 1746-1828*
LA NEVADA (THE SNOW STORM), 1786-87
Oil on canvas, 103⅜ × 110⅜ inches
Museo del Prado, Madrid

dent was probably viewed as the fall of Pride, and its sequel the triumph of Humility. It is the sort of moralizing common to medieval and Renaissance interpretations of winter. One of Pieter Bruegel the Elder's most famous and most influential paintings represents the citizens of a picturesque Flemish village cavorting on a frozen river or canal: skating, spinning tops, playing hockey, curling. Unlike a number of Bruegel's winter scenes, the mood is a gentle one, with the apparently innocent activities taking place beneath a hazy, golden sky that seems to promise imminent relief from the rigors of winter. Given the seductive charm of the painting, it is small wonder that it inspired not only scores of copies (cat. no. 15), but a whole tradition of Baroque winterscapes. Such seventeenth-century Dutch masters as Hendrick Avercamp (fig. 7) and Aert van der Neer made their reputations on the basis of winter scenes derived from Bruegel's little panel, preserving the lighthearted spirit and closely modulated color scheme of the original while amplifying and complicating the human activity taking place on the frozen canal. What Avercamp and the other winter specialists of the seventeenth century overlooked or chose to ignore, however, is the ominous implication of Bruegel's work, an implication revealed by a close examination of the painting's details.

Although the painting is often given the innocuous title *The Skaters*, an alternative and more revealing title is *The Bird Trap*, a reference to the primitive device found in the lower right quadrant of the painting. A dilapidated wooden door has been propped up with a stick, and birds are pecking at grain scattered around and beneath it. A string runs from the stick to the window of a nearby building, and once a number of birds have gathered beneath the door, the unseen trapper will pull the string and crush his prey. In a recent study of the painting, Linda and George Bauer show that the bird trap is a traditional symbol of the wiles and temptations of the Devil, as expressed in literary and visual similes that derive from biblical sources and resurface in the art and literature of the later Middle Ages.[7] Once we remember the allegorical inflections winter acquires in the medieval period, the message of Bruegel's painting appears subtly stated but unmistakable: while Man is thoughtlessly amusing himself on the frozen canal, the Devil lies in wait. Indeed, the apparent warmth of the winter sky may well be Bruegel's way of sug-

[7] Linda and George Bauer, "The *Winter Landscape with Skaters and Bird Trap* by Pieter Bruegel the Elder," *The Art Bulletin* (1984), 66:145–50.

gesting that the villagers are both literally and morally skating on thin ice. This line of interpretation receives confirmation from another of Bruegel's winter scenes: a study of skaters disporting themselves before the Gate of St. George in Antwerp. (The subject is represented in this exhibition by an engraving [cat. no. 14] after Bruegel's original drawing.) Once again, the scene appears to involve nothing more consequential than winter revelry, with various figures demonstrating their prowess or their clumsiness in contending with the slippery surface of the frozen canal. However, an inscription on the second state of the engraving for which Bruegel's design was the model refers to the "slipperiness of human life" (*lubricitas vitae humanae*). The concept survives

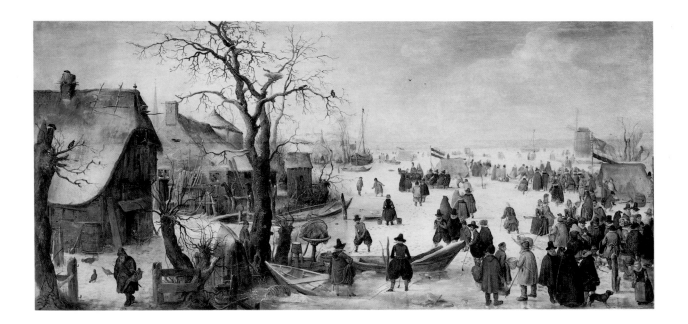

Figure 7. *Hendrick Avercamp, Dutch, 1585-1634*
WINTER SCENE ON A CANAL, ca. 1615
Oil on panel, 18⅞ × 37⅝ inches
Toledo Museum of Art, Gift of Edward Drummond Libbey

well into the seventeenth century, as the Bauers demonstrate by quoting George Wither's epigram for an emblem of a figure walking on ice:

We are all *Travelers*; and all of us
Have many passages, as dangerous,
As *Frozen-lakes*; and Slippery-wayes, we tread,
In which our lives may soon be forfeited,
(With all our hopes for life-eternall, too)
Unlesse, we well consider what we doe.[8]

In short, winter becomes a metaphor for the precariousness of life and man's spiritual vulnerability, and it is a trope with history behind it. Since winter is the darkest and coldest season of the year, Christian writers who associated Christ with the sun, and God's love with summer heat, naturally saw winter as the seasonal reminder of sin and the exile from grace. So Rabanus Maurus, the ninth-century theologian and encyclopedist, argued that winter suggested the period of darkness before the coming of Christ; and Dante, whose Paradise is a place of burning love, consigned the greatest villains of history to a Hell of bitter winds and eternal ice. Because the medieval mind saw in all aspects of the natural world the manifestation of God's will, it would have been virtually impossible to have ignored the "meaning" of winter: that the dark, cold, sunless skies and sterile landscape inevitably signified human depravity and its mortal consequence. When we describe a sudden conversion to more charitable ways as "a melting of the heart," we employ a figure of speech with Dickensian associations, but also with roots deep in the thought and art of the Middle Ages.

As it happened, the skaters of Bruegel's paintings and drawings were to glide innocently into subsequent generations of art history, oblivious to whatever moral or natural disasters may be implied by their recreation. In seventeenth-century depictions of the four seasons, winter is often represented by a skating scene (cat. no. 17), and the Flemish and Dutch painters who specialized in winterscapes inevitably made skating and other icy sports the principal activities of their human figures. There are no malevolent overtones in these works, just as there is nothing but sympathetic goodwill in nineteenth-century American artists' renderings of the same subject (cat. nos. 21 and 27). Indeed, Gilbert Stuart's famous portrait of William Grant skating in Hyde Park (fig. 8)

[8]Ibid. The passage is taken from *A Collection of Emblems* (London, 1635), ed. John Horden (Mewston, Yorkshire, 1968), p. 153.

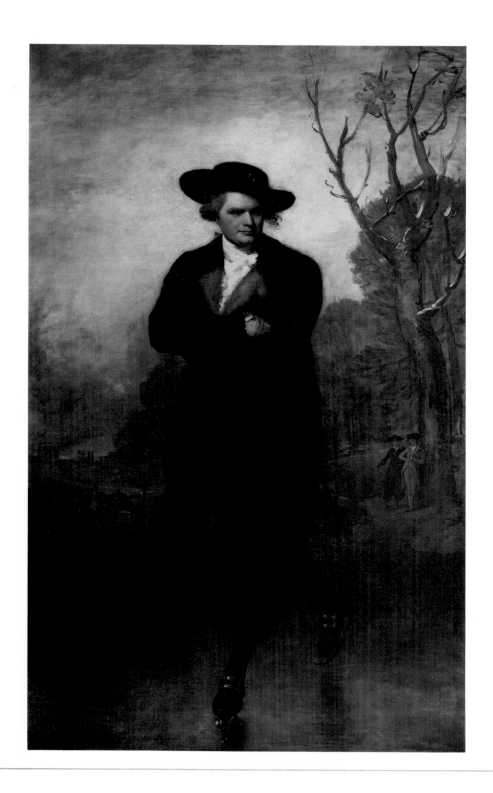

Figure 8. *Gilbert Stuart, American, 1755-1828*
THE SKATER (PORTRAIT OF WILLIAM GRANT), 1782
Oil on canvas, 96⅝ × 58⅛ inches
National Gallery of Art, Washington, D.C.; Andrew W. Mellon Collection

prompted an English critic to praise Grant's grace and "manly dignity," an appraisal that might have brought a cynical smile to the face of Pieter Bruegel, for whom skating and its potential disasters symbolized not grace but the Fall from Grace.

You must also seek to portray with
colours snow, hail, rainfall, frost,
rime, steaming, and dreary fogs, all
the things that are necessary to
depict melancholy winter days. . . .

Karel van Mander (1548–1606), The Painter's Book

Although the iconography of winter—its attributes and symbolic associations—is of primary interest to historians concerned with seasonal imagery in antique and medieval art, the student of landscape painting will focus upon the formal elements that begin to distinguish winter scenes in the first decades of the fifteenth century. When Pol Limbourg and his brothers contributed their calendar illustrations to *Les Très Riches Heures du Duc de Berry*, a new chapter in the history of landscape painting began, and as far as the winter landscape was concerned, it was the *first* chapter. I have commented on the miniature illustrating February in terms of its traditional iconography—peasants warming themselves at a fire, the cutting of firewood, a figure huddled against the cold—but it also stands as one of the first realistic landscapes of the modern period, and it is certainly the earliest surviving snow scene in Western art. It would be misleading, however, to credit the painters of the early Renaissance with the sympathetic response to winter we sense in the landscapes of later centuries. Outside of illustrated calendars and the paintings of Pieter Bruegel the Elder and his followers, snowy landscapes are in fact rare before 1600. However, beginning in the fifteenth century, northern European painters looked carefully at the natural world and, in line with evolving attitudes toward time and the cycles of life, recorded the changing appearance of the earth in ways that no medieval artist would have attempted. Acknowledging that the Nativity of Christ occurred in December and the Adoration of the Magi in early January, Hugo van der Goes set these events in landscapes whose leafless trees rise in dramatic silhouette against a chilly sky, a formal device that would become a stock item in the vocabulary of the winter landscapist

for centuries to come (cat. nos. 19 and 32). Bruegel employed the motif in his *Return from the Hunt*, and it has a modern sequel in the bare, bony trunks of Lawren Harris's *Above Lake Superior* (cat. no. 58) or in the delicate filigree of branches in Ralph Steiner's winter photographs (cat. no. 85). To remain for a moment with Bruegel's *Hunt*, it should be noted that the various components of this monumental landscape lived on in scores of later paintings devoted to the winter scene. The mill in the lower right corner of the composition, its wheel locked in an embrace of ice, recurs time and again in paintings such as Régis François Gignoux's *Winter Scene* (cat. no. 24); and the gathering and transporting of firewood, which Bruegel borrowed from the late medieval calendar pages, survives in the winterscapes of George Henry Durrie (cat. no. 25). (Such painters as Durrie, Gignoux, and John Henry Twachtman are American counterparts to the "winter specialists" of seventeenth-century Dutch landscape painting.) And as we have seen, Bruegel's hunters and skaters have a legion of descendants. One might argue that the recurrence of such details does not necessarily imply derivation, but in fact the great winter landscapists of the modern era have been well aware of the tradition initiated by Bruegel's paintings, if only through the hundreds of seventeenth-century sequels found in American and European collections. Even if we deal only with coincidental similarities, as is probably the case with Jasper Francis Cropsey's *North Conway, N.H.* (cat. no. 26) or Rockwell Kent's *The Trapper* (cat. no. 57), the striking kinship of these works to Bruegel's famous landscape underscores the durability of the genre.

Nature is never so lovely than when
it is snowing.

John Henry Twachtman (1853–1902)

As significant and interesting as are the various details and activities of these landscapes, the mood of a winter scene is established by two elementary if amorphous components: sky and snow. It has been justly stated that the real subject of seventeenth-century Dutch landscape painting is the sky, and when such masters as Jacob van Ruisdael or Aert van der Neer turned their attention to the winter landscape, they created skies that can chill the observer's blood. The black, turbulent clouds that

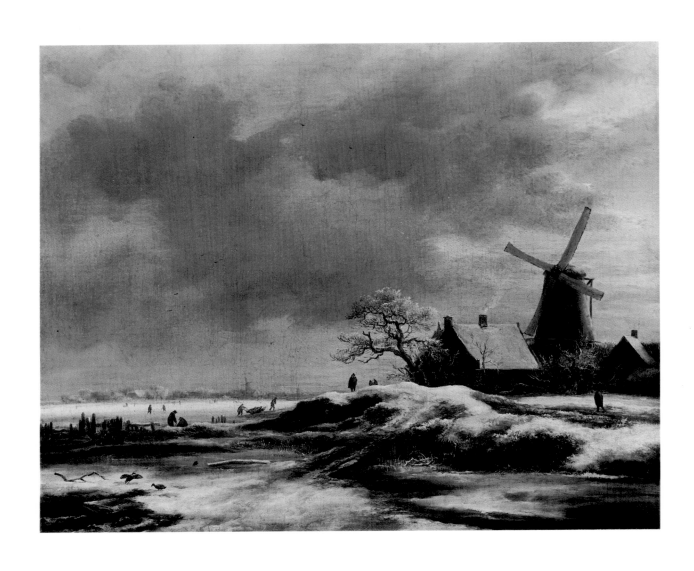

Figure 9. *Jacob van Ruisdael, Dutch, 1628/29-1682*
WINTER LANDSCAPE WITH A WINDMILL, ca. 1670
Oil on canvas, 14¾ × 18 inches
Fondation Custodia (collection of F. Lugt), Institut Néerlandais

dominate a Ruisdael composition (fig. 9) produce a mood of oppressive melancholy, a mood often reinforced by a shattered tree or a lonely windmill silhouetted against the sky. We look upon these paintings with eyes conditioned by the Romantic and Transcendentalist traditions of our own artistic and literary heritage, and our perspective may not be in line with the intent of the seventeenth-century artist or the interest of his patrons. And yet, that the crystalline charm of an Avercamp skating scene or the brooding grandeur of a Ruisdael winterscape reflect a heightened admiration for the shifting moods of nature and their psychological impact can hardly be questioned.

Snow is not so variable or dramatic as the winter sky, but it has the potential to reinforce the spirit of a landscape. Bruegel was probably the first Western artist to represent the actual fall of snow, which he does in his little panel of *The Adoration of the Magi in the Snow* (fig. 10). Without

Figure 10. *Pieter Bruegel the Elder, Flemish, 1525/30-1569*
THE ADORATION OF THE MAGI IN THE SNOW, 1567
Tempera on panel, 13¾ × 21¾ inches
Oskar Reinhart Collection "Am Romerholz," Winterthur, Switzerland

imputing a sort of Christmas-card mentality to Bruegel, there is no denying the aura of quiet intimacy these downy flakes contribute to the scene. It is exactly the mood generated by the snowfall in Robert Hills's *A Village Snow Scene* of 1819 (cat. no. 20), a work in which the forms and spirit of Bruegel's *Adoration* still resonate.

With Hills we return to the nineteenth-century landscape, whose gentle snowfalls persist in the works of our own era (witness Paul Signac's *Boulevard de Clichy* [cat. no. 45] or Willard Metcalf's *The White Veil* [cat. no. 48]). However, the winterscapes of the nineteenth century also include scenes of fearsome violence, particularly when seen against the rather pacific nature of eighteenth-century winter imagery. Considering the popularity of winter landscapes in the seventeenth century, the artists of the eighteenth seem surprisingly immune to the beauty or the drama of winter. The four seasons continue to appear in paintings, prints, and tapestries, and French masters such as Boucher have left us some charming if not very challenging studies of winter pastimes; but in contrast with the traditions of the Baroque era, winter seems rather tame in the age of the Rococo. With the nineteenth century, however, winter once more takes its place among the major categories of Western landscape painting, and it does so with a frightening intensity. Although no single explanation can ever account for the ebb and flow of a subject's popularity, it is clear that Romanticism promoted a fascination with the more dynamic and even threatening states of nature, and winter was such a state. As storm became a metaphor for any number of historical forces and human passions, Shakespeare's "furious winter rages" raged anew on the canvases of Europe and America. There were precedents for the winter storm motif. Poussin's *Deluge* is the winter component of his *Four Seasons*, possibly inspired by the traditional association of winter with death and rebirth, and the storms that abound in seventeenth-century Dutch marine paintings are sometimes winter storms. But it is William Turner, an admirer of both Poussin and Dutch landscape painting, whose paintings of snowstorms would introduce the modern era to the true rage of nature. Turner's *Valley of Aosta— Snowstorm, Avalanche and Thunderstorm* (fig. 11), which he painted after a trip to the Alps in 1836, is typical of the artist's desire to distill from his subject the very essence of nature's power. As in so many of Turner's paintings, this force is expressed as a vortex of elemental fury that both threatens and reduces to pathetic insignificance the human elements of

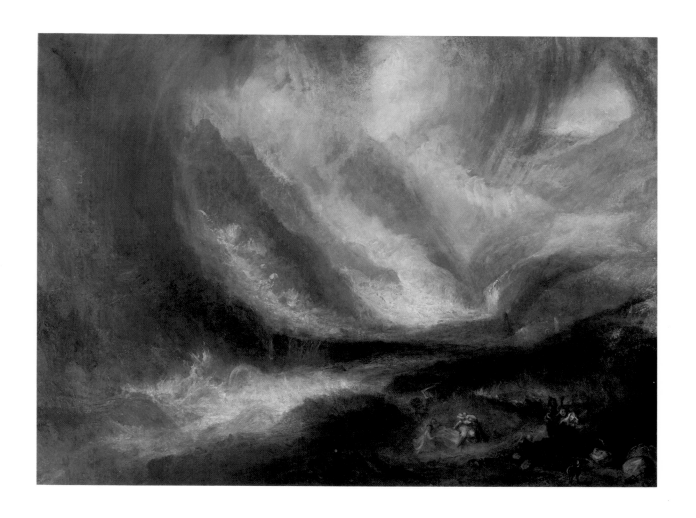

Figure 11. *Joseph Mallord William Turner, English, 1775-1851*
VALLEY OF AOSTA—SNOWSTORM, AVALANCHE AND
THUNDERSTORM, 1836/37
Oil on canvas, 36⅝ × 48½ inches
The Art Institute of Chicago, Frederick T. Haskell Collection

his composition. John Ruskin argued that the real subject of Turner's paintings was death, and although such a categorical appraisal has not been popular with Turner's modern critics, the suggestion of merciless forces embodied in his swirling snow clouds lends validity to Ruskin's intuition. The long-standing association of winter and human mortality is the theme on which Turner composes a sublime variation.

Although Turner's maelstroms constitute perhaps the most dramatic winter images of the nineteenth century, it was in France and Germany that winter found its wider audience. There both conservative and progressive camps adopted the winter landscape—the former, as a setting for historical narrative or spiritual revery; the latter, as an end in itself. In the Impressionist fascination with winter we encounter a gentle paradox, for at the very moment that European artists began to leave the warmth and safety of their studios to paint out-of-doors, they also began to take an interest in a subject that was more comfortably painted in the studio. To be sure, the familiar spring and summer settings of the Impressionists outnumber their winterscapes, but there exist scores of canvases on which Monet, Sisley, and Pissarro recorded their perceptions of winter in France. Camille Pissarro's *Piette's House at Montfoucault* (*Snow*) (cat. no. 40) is a masterful study of wet, leaden snow, whereas Paul Signac's *Boulevard de Clichy* (cat. no. 45) shows us that moment when the snow begins to "stick" on city streets. Not surprisingly, it is Claude Monet who created the most memorable of Impressionist winterscapes, whether he was exploring the lights and shadows surrounding a haystack standing in a snowy field (cat. no. 42), or observing the breakup of the ice on the Seine during the severe winter of 1880 (cat. no. 41). For Monet, any and all weather conditions provided the opportunity to explore the effects of light upon solid and not-so-solid forms, and the snow and skies of his winter scenes are as rich and subtle in their colors as are the fields and waters of his summer scenes.

The Impressionist technique was particularly suited to the recording of a snowfall, as Signac's painting proves and as the Impressionists of America discovered with enthusiasm. Childe Hassam's *Late Afternoon, New York: Winter* (cat. no. 47) is typical, and it is also typically American in its emphasis on motion and the implied passage of time. Monet's studies of haystacks in the snow or ice floes on the Seine mark the passage of seasonal or diurnal time in individual and sequential canvases. In contrast, Hassam's painting suggests both present and future: the heavi-

ness of the snowfall and its clearly stated motion herald a further accumulation, perhaps even the day-long storm that New Yorkers anticipate once or twice a year.

Hassam's painting provides a revealing point of comparison to Turner's frightening storm. For many artists of this continent, the faces of winter have been more familiar and consequently less threatening than for residents of milder climates. North Americans take a certain delight in the severity of their winters, a fact that subverts the traditional association of winter and despair. Indeed, for much of the United States and Canada, snow and ice are predictable constants and, like all of life's constants, form the stuff of poetry and nostalgia. The common denominator in paintings like Cropsey's *North Conway* (cat. no. 26) or Durrie's *Gathering Wood for Winter* (cat. no. 25) is the sort of seasonal contentment that made the prints of Currier and Ives the most popular landscapes in the history of American art.

As soon as the seasons are over, they
begin again. . . . All things are preserved
by dying. All things, from their destruction, are restored.
 Tertullian (ca. 160–ca. 230 A.D.)[9]

O God most wise, founder and governor of
the world, at whose behest the seasons
revolve in stated changes, like unto sere
death is Winter, whose desolateness and
hardship are the better borne because soon
to be succeeded by the amenity of Spring.
 Desiderius Erasmus (1466?–1536)[10]

Explicit or implicit in many of the works previously discussed is the notion that winter is a seasonal metaphor for death. While most of nature is only dormant in the winter months, her visual aspects—barren trees, withered vines, the funereal whiteness of snow, the ghostly pallor of the sky—inevitably suggest the death of the earth and, by implication, the death of man. Ancient and medieval literature abounds

[9]Tertullian, *Apologeticus*, English translation from *Apologetical Works and Minucius Felix Octavius*, trans. Sister Emily Joseph Daly (Washington, D.C., 1950), p. 119.
[10]Desiderius Erasmus, "Prayer for Winter," quoted in Roland Bainton, *Erasmus of Christendom* (New York, 1969), p. 245.

in wintry allusions to mortality. Bede, in one of his most memorable metaphors, compares human life to a bird that flies through an open window, is visible for a moment in a warm and fire-lit hall, and then escapes into the night, flying from "dark winter to dark winter."[11] When we speak of "the dead of winter," we echo a long-standing tradition of morbid associations.

In art, these associations can be symbolic or quite literal. Winter as a setting for death receives its boldest expression in nineteenth-century studies of wintry battles and snow-bogged retreats, many of them illustrating the military adventures of Napoleon. Jean-Louis-Ernest Meissonier's painting of Napoleon's campaign of 1814 is perhaps the most famous example of the genre, but the grimmest image is surely Baron Gros's *Battle of Eylau*, in which the emperor is surrounded by the corpses of men who have died on the snow-covered plain. The subject was to be repeated often, as in *The Retreat* of Jean-Baptiste-Edouard Detaille (cat. no. 36), one of Meissonier's pupils. Detaille records an incident in the Franco-Prussian War, a retreat taking place in the snows of a particularly bitter winter. This image of fallen men defeated by both nature and human cruelty is sadly international in scope. On this continent Frederic Remington created an American counterpart in his *Battle of War Bonnet Creek* (fig. 12), in which United States troopers stand triumphant over the bodies of Indian warriors stiffening in the snow. There is a terrible sense of inevitability in such images, as if the whole world were an icy, communal grave into which humanity deposits the victims of its wars. The poet Thomas Campbell expressed it perfectly in a stanza from his *Hohenlinden*: "Few, few shall part where many meet! / The snow shall be their winding sheet, / And every turf beneath their feet / Shall be a soldier's sepulchre."[12]

The stark realism of such paintings is in sharp contrast with another kind of nineteenth-century winterscape in which poetic sublimation is the principal approach. Caspar David Friedrich's *Cloister Graveyard in the Snow* (fig. 13) is the classic example, its barren trees and Gothic ruin echoing age-old references to death and the impermanence of human enterprise. In this as in so many other wintry scenes suggesting death, snow becomes a simile for shroud, and trees and ruined Gothic tracery remind one of the bony corpses depicted on late medieval tombs.

[11] Bede's metaphor is from the second book of his *Ecclesiastical History*, 2:13, published in Bede, *The Miscellaneous Works*, vol. 2, trans. J. A. Gibbs (London, 1891), p. 73.
[12] Thomas Campbell, *The Poetical Works of Thomas Campbell* (London, 1891), p. 73.

Figure 12. *Frederic Remington, American, 1861-1909*
BATTLE OF WAR BONNET CREEK
Oil on canvas, 26½ × 39 inches
The Thomas Gilcrease Institute of American History and Art, Tulsa, Oklahoma

The dead tree—and many of the trees prominently displayed in such paintings are clearly dead—is one of the most enduring symbols in this tradition. In woodcut and engraved illustrations to Cesare Ripa's *Iconologia*, the Renaissance compendium of symbols and allegories cited earlier in this essay, the personification of winter sits disconsolate beneath a barren tree, and this same dead tree becomes an isolated symbol of winter in other emblematic representations of the year. Whether George Henry Durrie was consciously faithful to this tradition in placing a large, shattered oak in the foreground of his *Gathering Wood for Winter* (cat. no. 25) is an unanswerable question, but the suggestion of mortality is inescapable, just as it is in Grant Wood's *January* (cat. no. 67). In the latter work, the American Regionalist marshals his snow-capped corn shocks like so many hooded mourners on a Burgundian tomb.

If one examines Durrie's painting closely, however, one discovers that the blasted tree is only apparently dead, that there are live shoots springing from its ruined trunk. Regardless of Durrie's intention, this emergence of life from apparent death is a leitmotif running throughout Western attitudes toward winter. Winter gives way to spring, and this seasonal renewal is linked just as inevitably to concepts of rebirth and immortality. From Tertullian's *Apologeticus* to Erasmus's *Winter Prayer*, the medieval Christian world compared the reawakening of nature to the resurrection of the body, as well as to man's rebirth in Baptism and the advent of the Era of Grace. It is the season of spring that realizes and symbolizes this renewal, but winter holds the promise, and the promise is often stated. The labor of February in medieval sculpture and manuscripts is sometimes the pruning of trees, an activity intimately linked to the idea that life springs from death. It is probably no accident that Pieter Bruegel the Elder included this activity in the foreground of his *Adoration of the Magi in the Snow*, for there it can serve both as a labor of the season and as a symbolic reference to the death of the Old Era and the birth of the New.

American artists have been particularly interested in the forward-looking aspects and activities of winter, from Eastman Johnson's *Sugaring Off* (cat. no. 29) and John Henry Twachtman's *End of Winter* (cat. no. 46) to Ernest Lawson's *Spring Thaw* (cat. no. 49). The last of these, incidentally, bears a remarkable resemblance to Monet's famous series of paintings of the breakup of the ice on the Seine (cat. no. 41). In the case of the Monets, however, the "heartbreaking beauty" of the scene (the

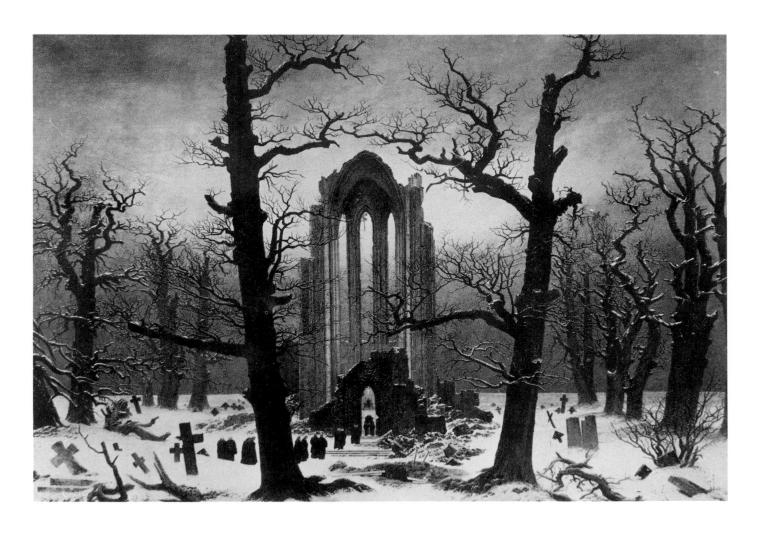

Figure 13. *Caspar David Friedrich, German, 1774-1840*
CLOISTER GRAVEYARD IN THE SNOW, 1817-19
Oil on canvas, approx. 48 × 67 inches
Nationalgalerie, Berlin (destroyed 1945)

words are those of Alice Hoschedé,[13] a friend of Monet) belies the destructive forces of the winter thaw. In 1880, the year in which the series was painted, France experienced a winter of bitter cold and deep snow, and a sudden January thaw brought a terrifying flood of water and ice. This violence of nature reborn, so often apparent in the birth pangs of spring, is the concomitant of the optimism that attends the passing of winter, and it finds its expression in Charles Burchfield's mystical *March Wind* (cat. no. 70), a painting whose aggressive thrust seems to qualify Burchfield's stated belief in the "beneficent God in nature."

The cold moon rising—
Among many withered limbs,
Three shoots of green bamboo.

Freezing wintry wind
Splitting into the rock
The sound of water

Two haiku *by Yosa Buson (1716–1784)*

The Japanese poet and painter Yosa Buson left to his many followers a legacy of both winter *haiku* and winter landscapes. His influence is represented in this exhibition by the hanging scroll by Matsumura Goshun (Gekkei) entitled *The Road to Shu* (cat. no. 5), in which travelers make their way along a steep mountain path amid barren trees and snow-covered precipices. The painting represents a tradition of landscape painting that begins in China and finds some of its earliest and most monumental winter scenes in the work of artists such as Li Cheng (Li Ch'eng). In the Ming dynasty, Shen Zhou (Shen Chou) (cat. no. 1) and Wen Zhengming (Wen Cheng-ming) (cat. no. 2) continue the tradition with winterscapes that evoke the mystical and philosophical roots of Chinese landscape painting. It is interesting that Wen Zhengming is virtually the contemporary of Pieter Bruegel the Elder, for there is a remarkable affinity between Chinese landscapes and those of the sixteenth-century Flemish master, an affinity that reflects not an East-West exchange of artistic concepts (unlikely at this date), but rather certain parallels between the Taoist and Confucian base of Chinese landscape

[13]Alice Hoschedé is quoted in Joel Isaacson, *The Crisis of Impressionism: 1878–1882* (Ann Arbor, 1980), p. 133.

painting and the pantheistic and neo-Stoic overtones of Bruegel's works. In both traditions, the laws of nature and the eternal cycle of the seasons serve as the context for human activity perfectly integrated with the life of the earth.

Bruegel also would have appreciated the Japanese landscapes of later generations. Yokoi Kinkoku (cat. nos. 6–8), another follower of Buson, created winter scenes as intimate as Bruegel's *Adoration*; and by spattering the surface of his paintings with white ink (a technique rare but not unknown in Chinese painting), he created the same effect of softly falling snow. In style, however, Kinkoku's paintings are more akin to those of the Impressionists, with their swift, spontaneous rendering of landscape details. In fact, the poem that Kinkoku inscribed on one of the paintings in this exhibition could just as easily serve as an inscription for Pissarro's *Piette's House at Montfoucault* (cat. no. 40): "The World has a new kind of jeweled tree; / Half a step out of the door and I feel the cold wind."[14]

That cold wind also chills the observer of Utagawa Kuniyoshi's woodcut of a woman in the snow (cat. no. 9), a figure that recalls the bundled personifications of winter in ancient and medieval art of the West. While such comparisons may be of no art-historical consequence—we deal here with coincidence and not influence—such parallels underscore the universal theme running through almost all of the works in this exhibition: the idea that this most hostile of seasons demands a human accommodation that can be elegant in its success, tragic in its failure, and as constant in its necessity as the facts of life and death.

BIBLIOGRAPHICAL NOTE

In addition to the sources cited in the footnotes, the following works may be of interest to the general reader.

Grossman, Fritz. *Pieter Bruegel the Elder: Complete Edition of the Paintings.* London, 1973. This study includes reproductions and analyses of Bruegel's winter scenes.

Hutson, Martha. *George Henry Durrie.* Laguna Beach, 1977. This scholarly study of the American landscape painter includes a comprehensive introduction to the subject of winter in American art.

[14] The translation is by Jonathan Chaves, quoted in Stephen Addiss, *Zenga and Nanga, Paintings by Japanese Monks and Scholars* (New Orleans, 1976), p. 124. The two *haiku* by Buson that introduce the last section of this essay are transcribed and translated in Calvin French, *The Poet-Painters: Buson and his Followers* (Ann Arbor, 1974), pp. 71, 78.

Lee, Sherman. *Chinese Landscape Painting*. London, 1962. A good introduction to the subject, this work includes a number of major winterscapes and a discussion of the philosophical bases of Chinese landscape painting.

Nasgaard, Roald. *The Mystic North: Symbolist Landscape Painting in Northern Europe and North America 1890–1940*. Toronto, 1984. This catalogue of the memorable exhibition of landscape painting at the Art Gallery of Ontario contains a thorough analysis of the philosophical and psychological foundation of its subject.

Stechow, Wolfgang. *Dutch Landscape Painting of the Seventeenth Century*. London, 1966. The work includes a history of the winter landscape in Dutch art and its antecedents in fifteenth- and sixteenth-century northern painting.

CATALOGUE
OF THE EXHIBITION

1. *Shen Zhou (Shen Chou), Chinese, 1427–1509*
 SNOW SCENE *with calligraphy and poem by the artist, from* SCENES OF SUZHOU
 AND VICINITIES, *between 1484 and 1504*

 Ink and light color on paper, album leaf, 13⅜ × 23⁵⁄₁₆ inches
 Collection of Mr. and Mrs. Wan-go H. C. Weng

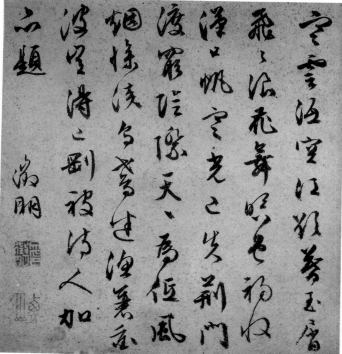

2. *Wen Zhengming (Wen Cheng-ming), Chinese, 1470–1559*
SNOW SCENE *with calligraphy and poem by the artist, from* EIGHT SCENES OF XIAO XIANG
Ink and light color on paper, album leaf, 8¹¹⁄₁₆ × 8⅛ inches; calligraphy 9¹⁄₁₆ × 8⁷⁄₁₆ inches
Collection of Mr. and Mrs. Wan-go H. C. Weng

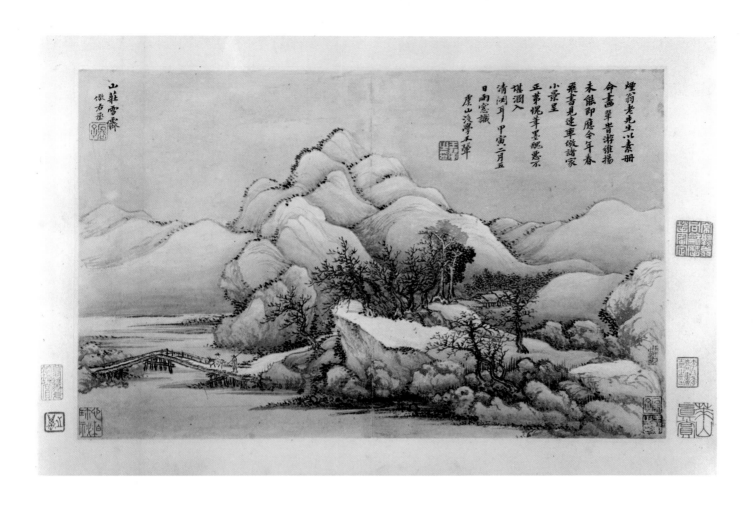

3. *Wang Hui, Chinese, 1632–1717*

WINTER SCENE *from* LANDSCAPES AFTER ANCIENTS, *1674*

Ink and light color on paper, album leaf, 8¹¹⁄₁₆ × 13¼ inches
Collection of Mr. and Mrs. Wan-go H. C. Weng

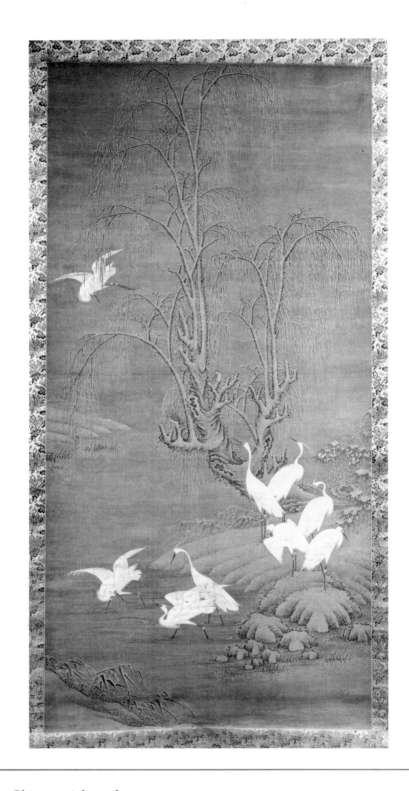

4. *Unknown, Chinese, eighteenth century*

NINE EGRETS IN A SNOWY LANDSCAPE

Ink and light color on silk, hanging scroll, 51 × 24 inches
Hood Museum of Art, Dartmouth College, Gift of Mr. and Mrs. D. Herbert Beskind, Class of 1936

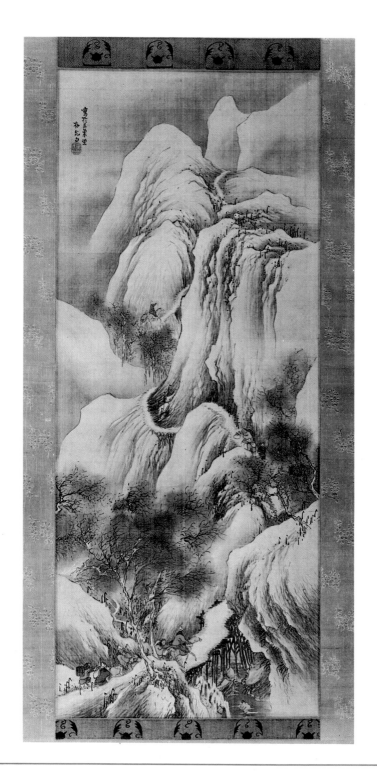

5. *Matsumura Goshun (Gekkei), Japanese, Edo period, 1752–1811*

THE ROAD TO SHU, *ca. 1780–81*

Ink and color on silk, hanging scroll, 50⅝ × 19¾ inches
The University of Michigan Museum of Art, Margaret Watson Parker Art Collection, 1970/2.152

6. *Yokoi Kinkoku, Japanese, 1761–1832*

WINTER LANDSCAPE

Sumi and color on paper, 11⅞ × 6⅜ inches
Collection of Kurt and Millie Gitter

7. *Yokoi Kinkoku, Japanese, 1761–1832*

WINTER LANDSCAPE

Sumi and color on paper, 11⅞ × 6⅜ inches
Collection of Kurt and Millie Gitter

8. *Yokoi Kinkoku, Japanese, 1761–1832*

WINTER LANDSCAPE

Sumi and color on paper, 11⅞ × 6⅜ inches
Collection of Kurt and Millie Gitter

9. *Utagawa Kuniyoshi, Japanese, 1798–1861*

BLACK TURBAN, *ca. 1828*

Woodblock print, 8¼ × 7 inches
Museum of Fine Arts, Springfield, Massachusetts, The Raymond A. Bidwell Collection

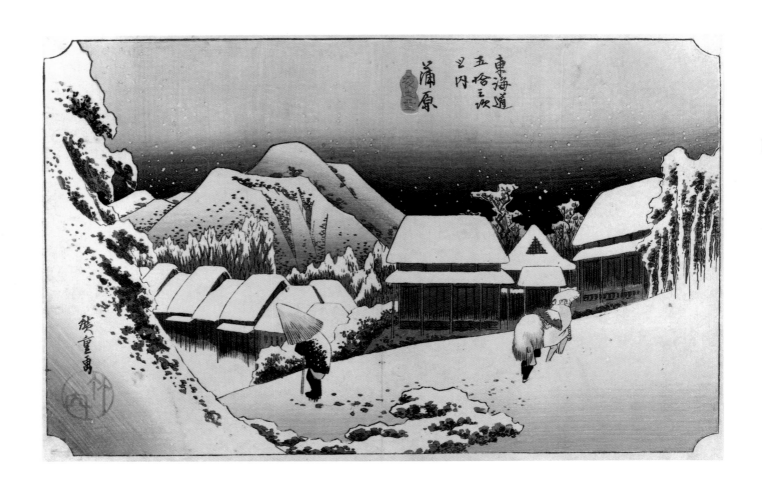

10. *Utagawa (Andō) Hiroshige, Japanese, 1797–1858*

KAMBARA, NIGHT SNOW, *from the series* THE GREAT TŌKAIDŌ, *1834*

Woodblock print, 8⅞ × 14 inches
Hood Museum of Art, Dartmouth College, Gift of John C. Richardson, Class of 1941, in memory of his father,
 Edward C. Richardson, Class of 1905

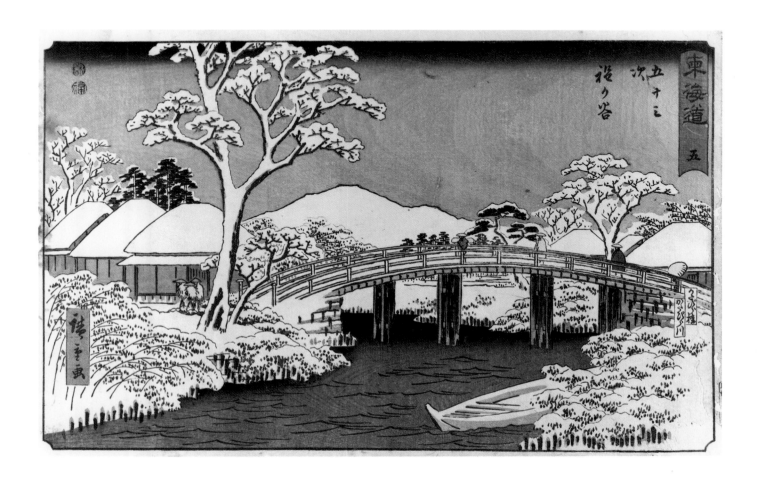

11. *Utagawa (Andō) Hiroshige, Japanese, 1797–1858*

HODOGAYA, *from the series* THE REISHO TŌKAIDŌ, *1842–53*

Woodblock print, 8⅝ × 13¾ inches

Hood Museum of Art, Dartmouth College, Gift of John C. Richardson, Class of 1941, in memory of his father,
* Edward C. Richardson, Class of 1905*

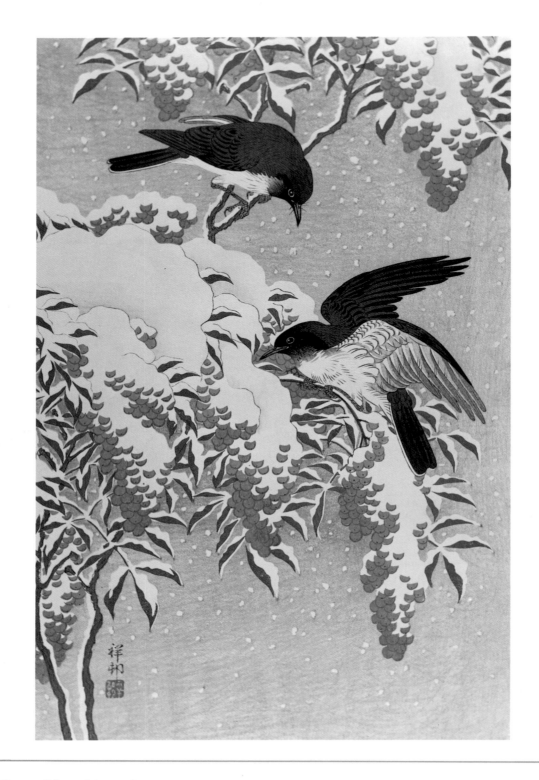

12. *Shoson Ohara-Matao, Japanese, 1898–1945*

NANTEN BUSH AND FLY CATCHERS IN THE SNOW, *1929*

Woodblock print, 14⅜ × 9½ inches
The University of Michigan Museum of Art, 1930.66

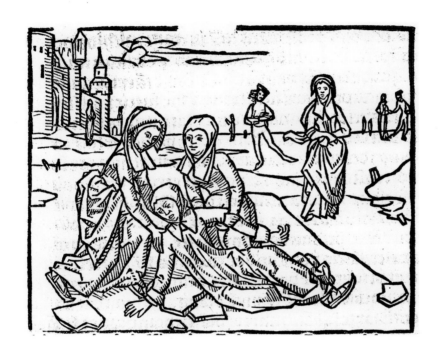

13. *Unknown, Dutch, fifteenth century*

UNTITLED (LUDWINA FALLING ON ICE), *from an incunable by J. Brugman,*
VITA LIDWINAE, *published in 1498*

Woodcut, 3 × 3¾ inches
The Pierpont Morgan Library

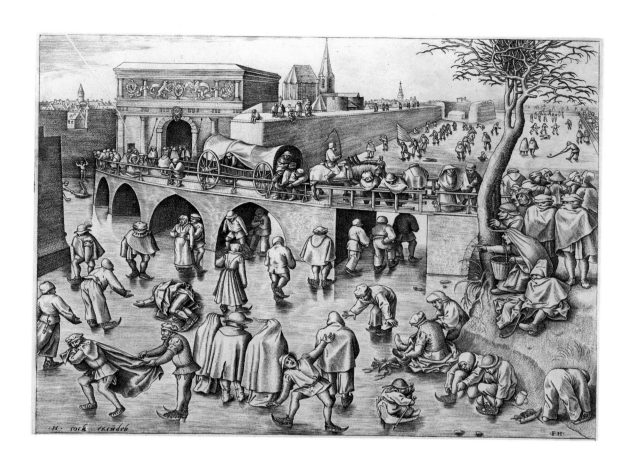

14. *Frans Huys, Dutch, 1522–1562, after drawing by Pieter Bruegel the Elder, Flemish, 1525/30–1569*

SKATERS BEFORE THE GATE OF ST. GEORGE IN ANTWERP, *1558–59*

Engraving, 9⅛ × 11¾ inches

Museum of Fine Arts, Boston, Stephen Bullard Memorial Fund, 66.349

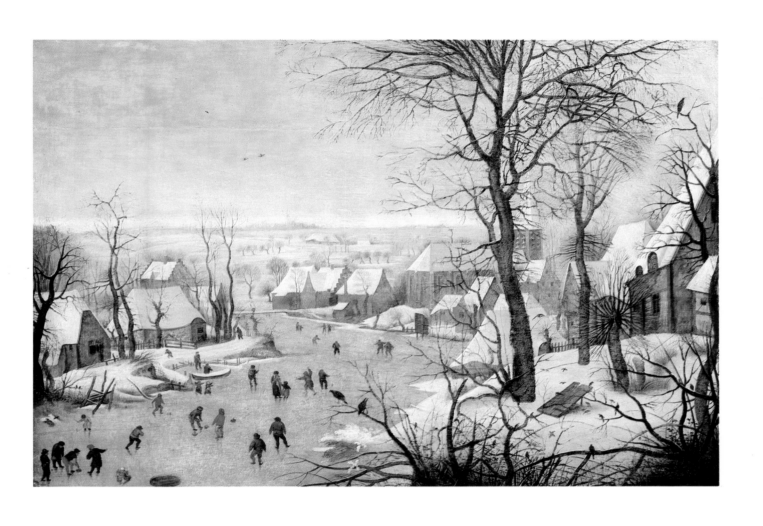

15. *School of Pieter Bruegel the Elder, Flemish, 1525/30–1569*

LANDSCAPE WITH BIRD TRAP

Oil on panel, 15 × 22 inches
Collection of Frederick and Jan Mayer

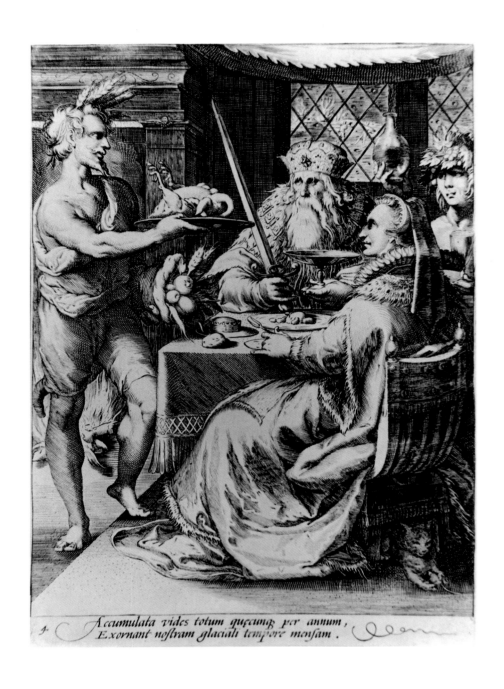

16. *Jan Saenredam, Dutch, 1565–1607, after Hendrik Goltzius, Dutch, 1558–1617*

WINTER, *from* THE FOUR SEASONS, *ca. 1600*

Engraving, only state, 8 × 5¾ inches
Mead Art Museum, Amherst College, Museum Purchase, 1971.6

17. *Hessel Gerrytsz, Dutch, 1581–1632, after David Vinckboons, Flemish, 1578–1629*

WINTER, *from* THE SEASONS: VIEWS OF CASTLES IN THE VICINITY OF AMSTERDAM

Etching, 7⅞ × 10⅝ inches
Hood Museum of Art, Dartmouth College, Purchase

18. *Pieter Molijn, Dutch 1595–1661*

WINTER LANDSCAPE, *1656*

Black chalk, gray wash, 5¾ × 7⅝ inches
The Pierpont Morgan Library

19. *George Morland, English, 1763–1804*

WINTER LANDSCAPE

Oil on canvas, 14 × 15½ inches
Hood Museum of Art, Dartmouth College, Gift of Mr. and Mrs. M. R. Schweitzer

20. *Robert Hills, English, 1769–1844*

A VILLAGE SNOW SCENE, *1819*

Watercolor, touches of bodycolor, scraping out over pencil, 12¾ × 16⅞ inches
Yale Center for British Art, Paul Mellon Collection

21. *Thomas Sully, American, 1783–1872*

SKATER

Oil on paper, 9⅛ × 8⅛ inches
Hood Museum of Art, Dartmouth College, Gift of Mr. and Mrs. Richard Harriss in memory of their son, Wayne Ewing Harriss

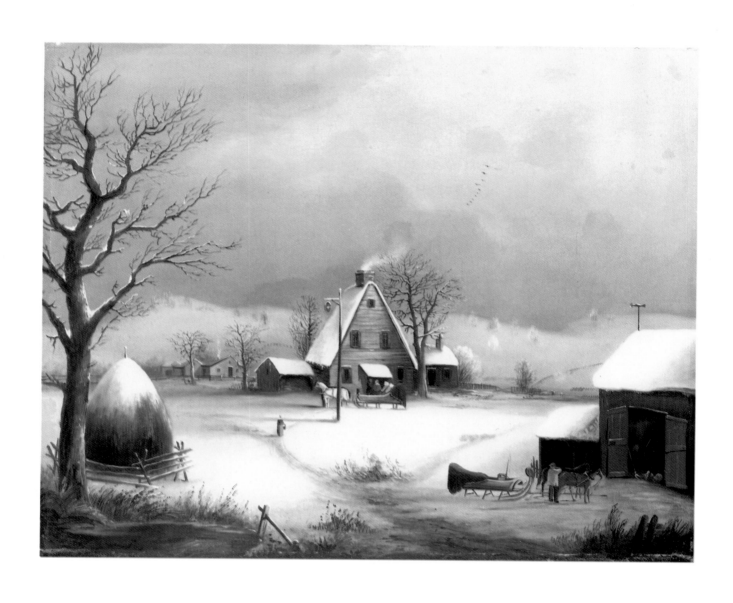

22. *William Matthew Prior, American, 1806–1873, attributed to*

IN WITH THE SLEIGH

Oil on canvas laid down on composition board, 23½ × 28¾ inches
Anonymous Lender

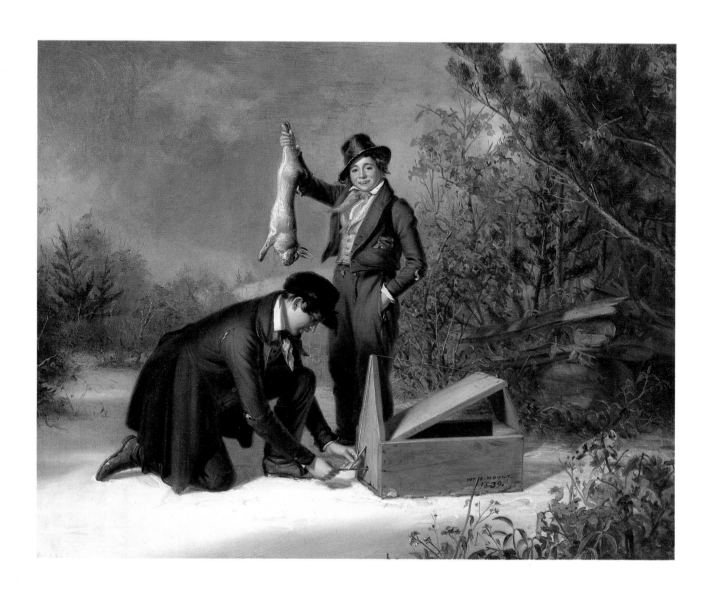

23. *William Sidney Mount, American, 1807–1868*

CATCHING RABBITS (BOYS TRAPPING), *1839*

Oil on panel, 18¼ × 21⅜ inches
The Museums at Stony Brook, New York, Gift of Mr. and Mrs. Ward Melville, 1958

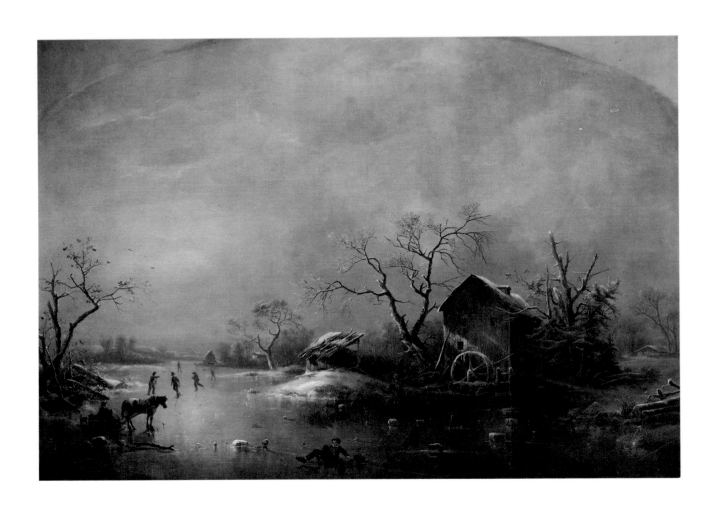

24. *Régis François Gignoux, French, 1814–1882 (worked in America 1840–1870)*

WINTER SCENE, *1850*

Oil on canvas, 36 × 50¼ inches
The Corcoran Gallery of Art, Gift of William Wilson Corcoran

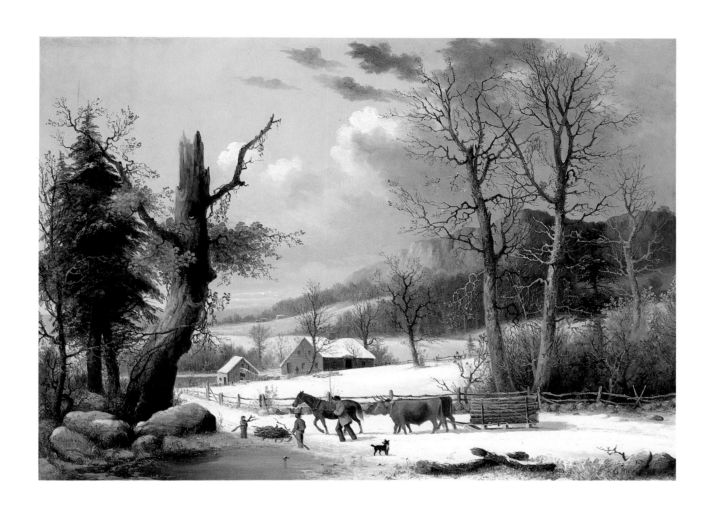

25. *George Henry Durrie, American, 1820–1863*

GATHERING WOOD FOR WINTER, *1855*

Oil on canvas, 26 × 36 inches
Collection of William Nathaniel Banks

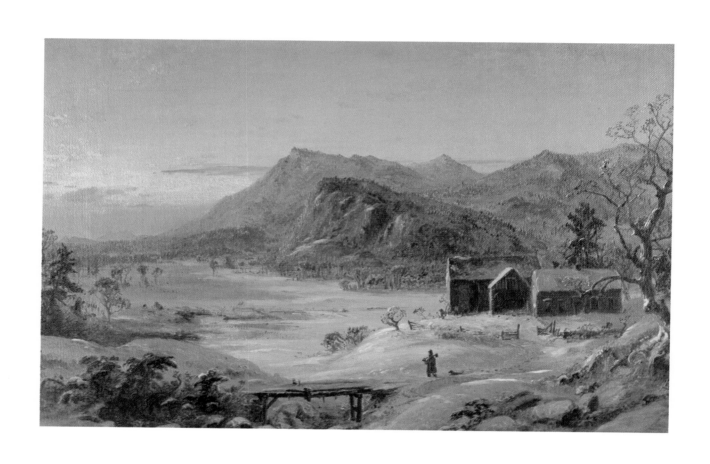

26. *Jasper Francis Cropsey, American, 1823–1900*

WINTER LANDSCAPE, NORTH CONWAY, N.H., *1859*

Oil on canvas, 10¼ × 16½ inches
Collection of Henry Melville Fuller

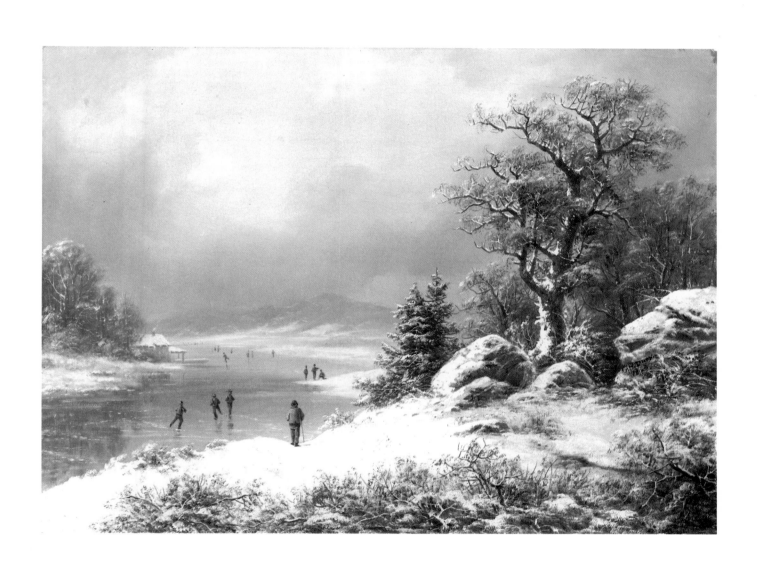

27. *George Henry Durrie, American, 1820–1863*

SKATING ON THE CONNECTICUT RIVER, *1862*

Oil on canvas, 24⅛ × 32 inches
Anonymous Lender

WINTER

28. *Jean-Baptiste-Adolphe Lafosse, French, 1810–1879, after Felix Octavius Carr Darley, American, 1822–1888*

WINTER, *from* DARLEY'S AMERICAN FARM SERIES, *1860*

Color lithograph, 13¼ × 18½ inches
Hood Museum of Art, Dartmouth College, Whittier Fund

29. *Eastman Johnson, American, 1824–1906*

SUGARING OFF, *ca. 1861–66*

Oil on canvas, 52¾ × 96½ inches
Museum of Art, Rhode Island School of Design, Museum Works of Art Fund

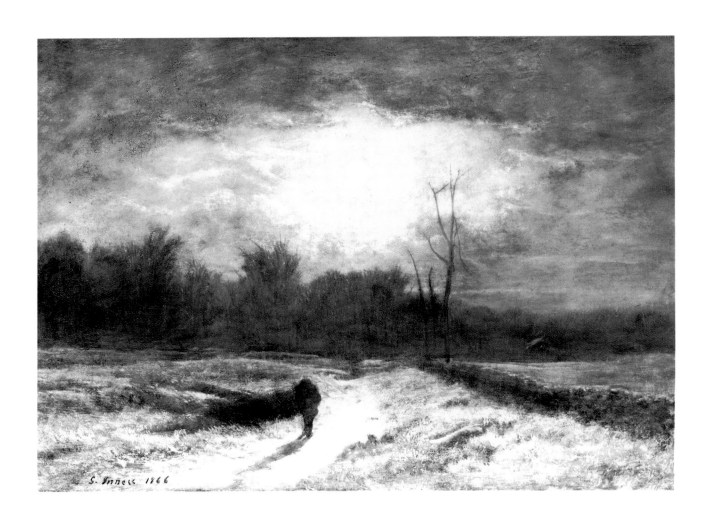

30. *George Inness, American, 1825–1894*

CHRISTMAS EVE, *1866*

Oil on canvas, 22 × 30 inches
Montclair Art Museum, Montclair, New Jersey, Museum Purchase, 1948

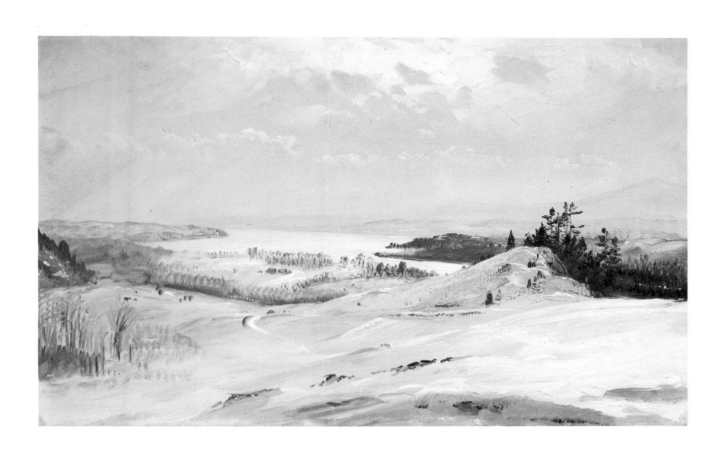

31. *Frederic Edwin Church, American, 1826–1900*

WINTER LANDSCAPE FROM OLANA, *1870–71*

Oil on paper mounted on composition board, 11¾ × 18¼ inches
New York State Office of Parks, Recreation and Historic Preservation, Bureau of Historic Sites, Olana State Historic Site,
 Taconic Region

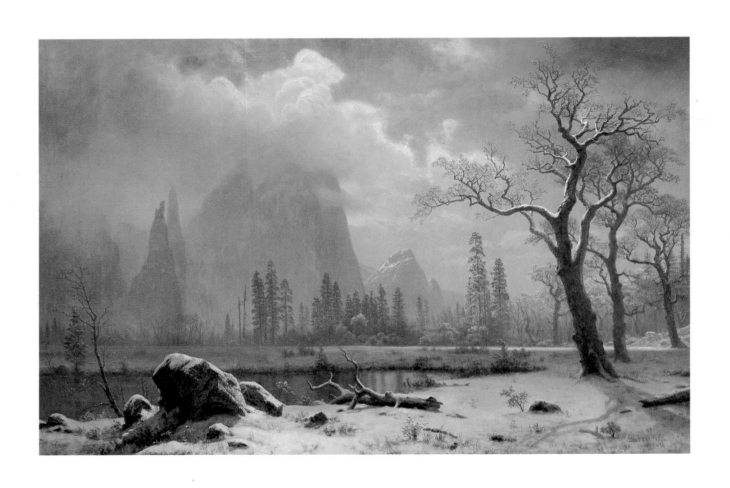

32. *Albert Bierstadt, American, 1830–1902*

YOSEMITE WINTER SCENE, *1872*

Oil on canvas, 32⅛ × 48⅛ inches
University Art Museum, University of California, Berkeley, Gift of Henry D. Bacon

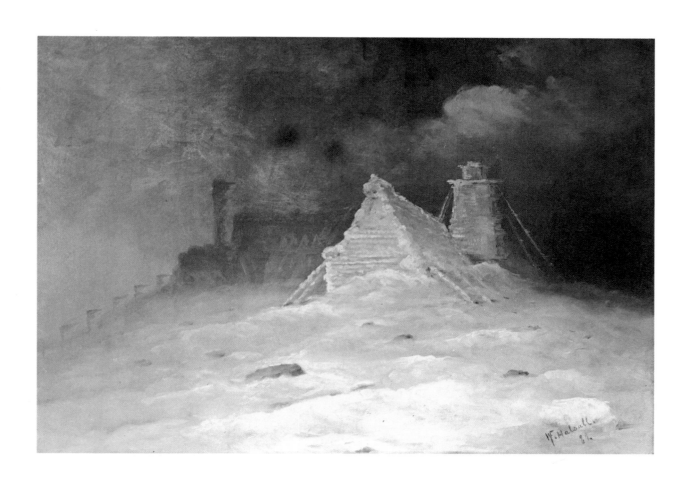

33. *William Formby Halsall, American, born England, 1841–1919*

SUMMIT OF MOUNT WASHINGTON IN WINTER, *1889*

Oil on canvas, 19 × 27 inches
Littleton Public Library, Littleton, New Hampshire

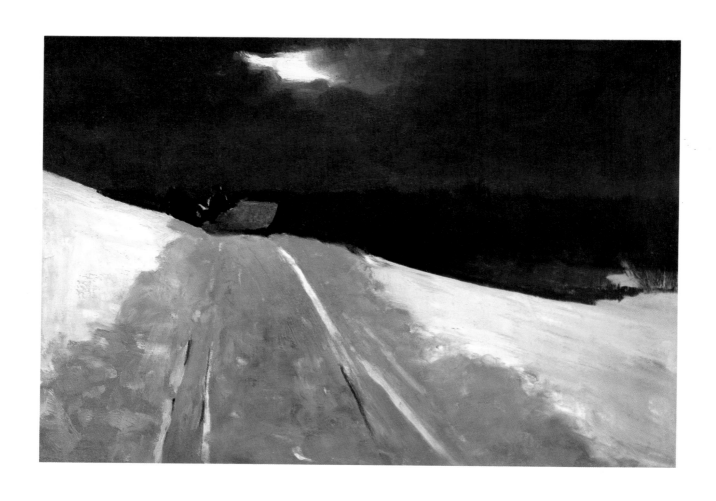

34. *Winslow Homer, American, 1836–1910*

SLEIGH RIDE, *ca. 1893*

Oil on canvas, 14¹⁄₁₆ × 20¹⁄₁₆ inches
Sterling and Francine Clark Art Institute, Williamstown, Massachusetts

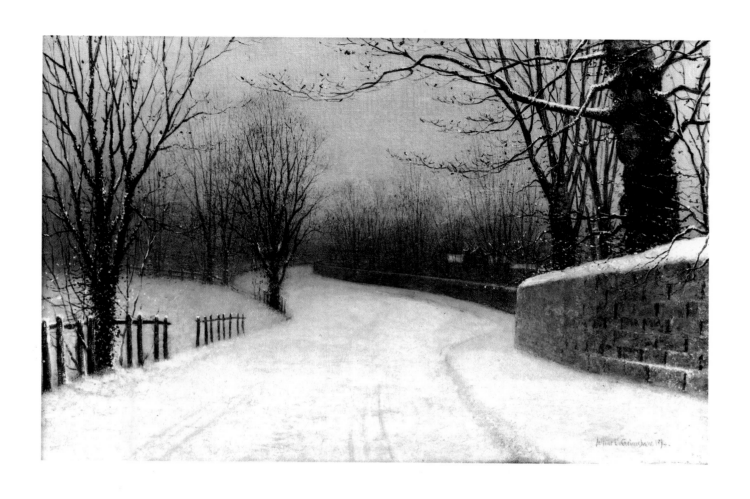

35. *Arthur E. Grimshaw, English, 1868–1913*

A WINTER LANE, *1894*

Oil on canvas, 18 × 11¾ inches
Collection of Mr. and Mrs. Peter Heydon, Ann Arbor, Michigan

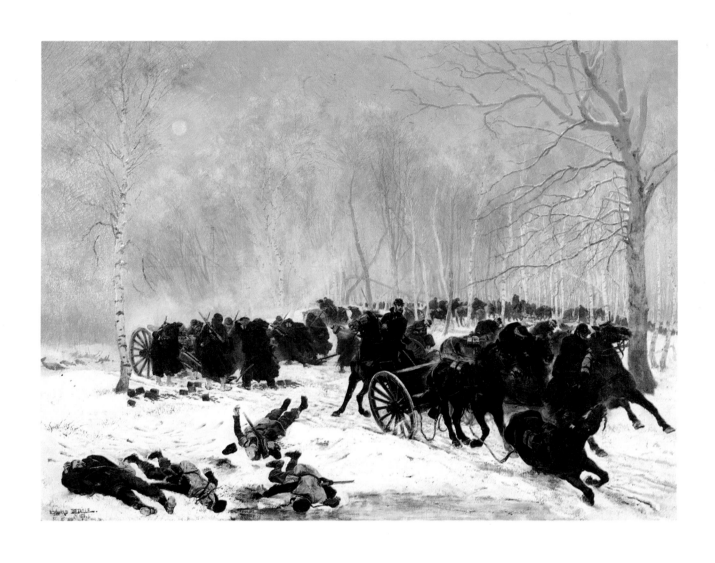

36. *Jean-Baptiste-Edouard Detaille, French, 1848–1912*

THE RETREAT, *or* FRENCH ARTILLERY, *1873*

Oil on canvas, 49 × 63 inches
John and Mable Ringling Museum of Art

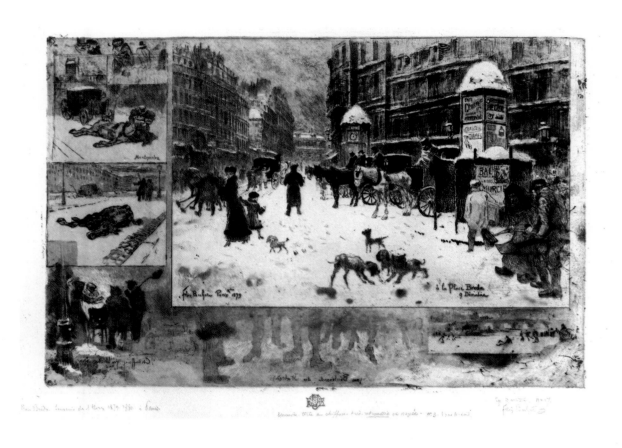

37. *Félix-Hilaire Buhot, French, 1847–1898*

WINTER IN PARIS, *or* PARIS IN THE SNOW, *1879–80*

Etching, aquatint, soft-ground, drypoint, and roulette on greenish laid paper; third state of nine, artist's proof before publication,
 9⅜ × 13¾ inches
Collection of Carol and James Goodfriend

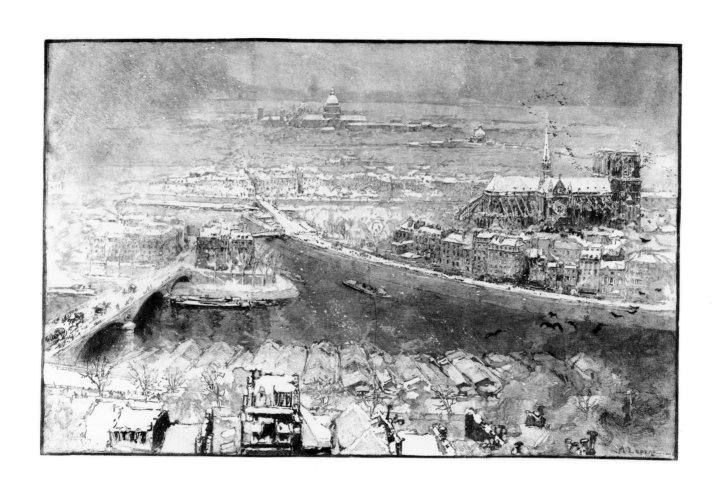

38. *Louis-Auguste Lepère, French, 1849–1918*

PARIS IN THE SNOW, MORNING OF MARCH 1, 1890, FROM THE TOWER OF
SAINT-GERVAIS, *1890*

Wood engraving, 11⅞ × 17½ inches
Collection of Carol and James Goodfriend

39. *Jean-Barthold Jongkind, Dutch, 1819–1891*

WINTER SCENE, *ca. 1865*

Oil on panel, 7⅛ × 12⅜ inches
The Kempe Collection

40. *Camille Pissarro, French, 1830–1903*

PIETTE'S HOUSE AT MONTFOUCAULT (SNOW), *1874*

Oil on canvas, 18⅛ × 26⅝ inches
Sterling and Francine Clark Art Institute, Williamstown, Massachusetts

41. *Claude Monet, French, 1840–1926*

THE FLOATING ICE, *1880*

Oil on canvas, 38¼ × 58¼ inches
Shelburne Museum, Shelburne, Vermont

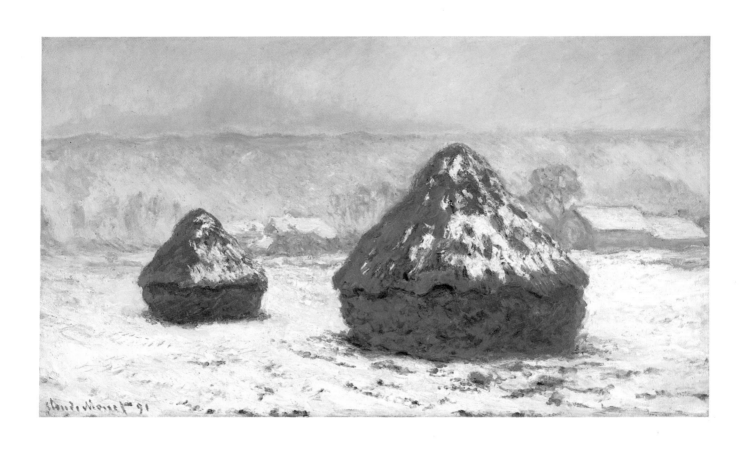

42. *Claude Monet, French, 1840–1926*

HAYSTACKS IN THE SNOW, *1891*

Oil on canvas, 23½ × 39½ inches
Shelburne Museum, Shelburne, Vermont

43. *Vincent van Gogh, Dutch, 1853–1890*

ROAD NEAR NUENEN, *1881*

Chalk, pencil, pastel, and watercolor, 15½ × 22¾ inches
The Metropolitan Museum of Art, Robert Lehman Collection, 1975 (1975.1.774)

44. *Vincent van Gogh, Dutch, 1853–1890*
GARDEN OF THE RECTORY AT NUENEN, *1885*

Oil on canvas, mounted on panel, 20⅞ × 30¾ inches
The Armand Hammer Foundation

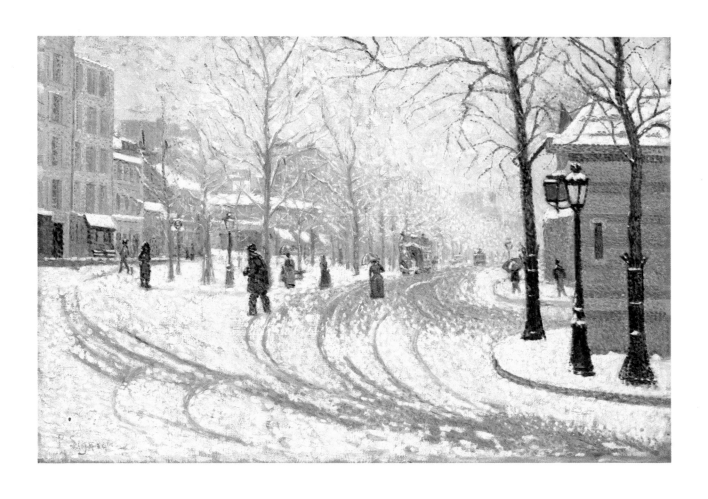

45. *Paul Signac, French, 1863–1935*

BOULEVARD DE CLICHY, *1886*

Oil on canvas, 18⅝₁₆ × 25¹³⁄₁₆ inches
The Minneapolis Institute of Arts, Bequest of Putnam Dana McMillan

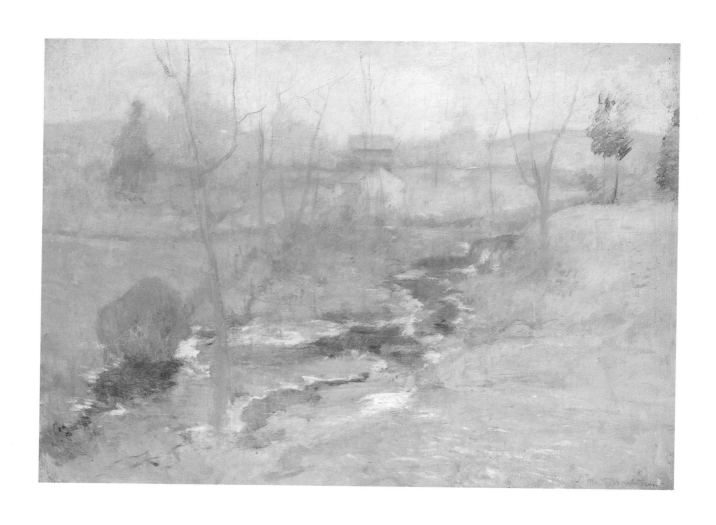

46. *John Henry Twachtman, American, 1853–1902*

END OF WINTER, *after 1889*

Oil on canvas, 22 × 30⅛ inches
National Museum of American Art, Smithsonian Institution, Gift of William T. Evans

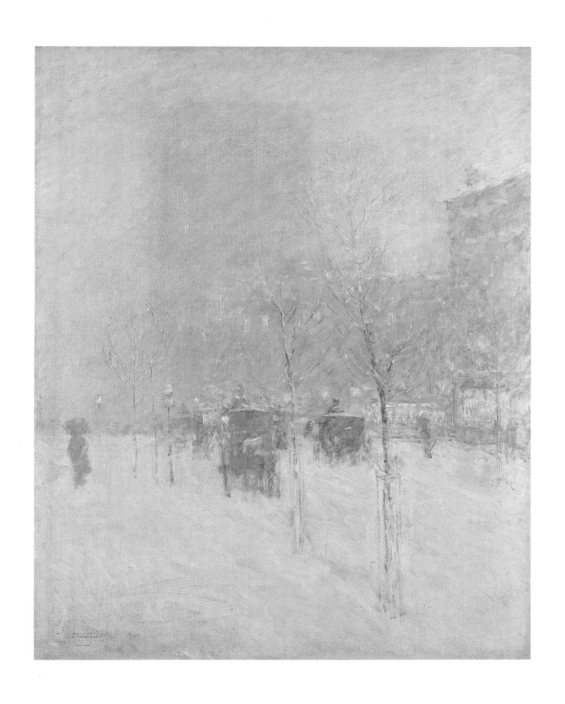

47. *Childe Hassam, American, 1859–1935*

LATE AFTERNOON, NEW YORK: WINTER, *1900*

Oil on canvas, 37¼ × 29⅛ inches
The Brooklyn Museum, Dick S. Ramsay Fund

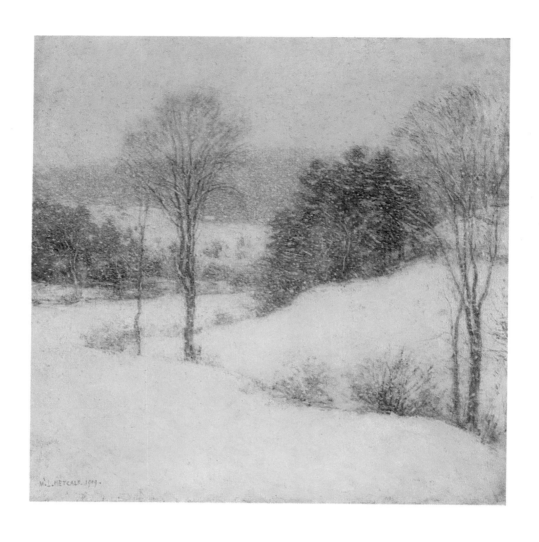

48. *Willard L. Metcalf, American, 1858–1925*

THE WHITE VEIL, *1909*

Oil on canvas, 24 × 24 inches
Museum of Art, Rhode Island School of Design, Gift of Mrs. Gustav Radeke

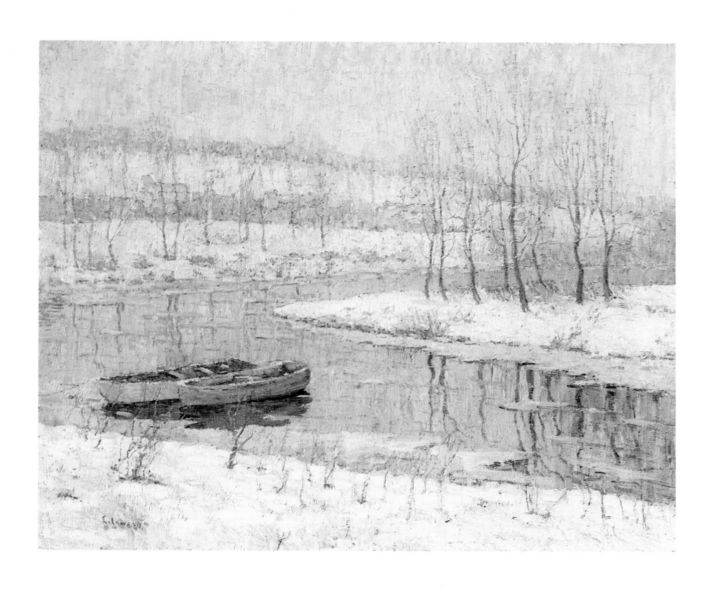

49. *Ernest Lawson, American, 1873–1939*

SPRING THAW

Oil on canvas, 25 × 30 inches
Daniel J. Terra Collection, Terra Museum of American Art, Evanston, Illinois

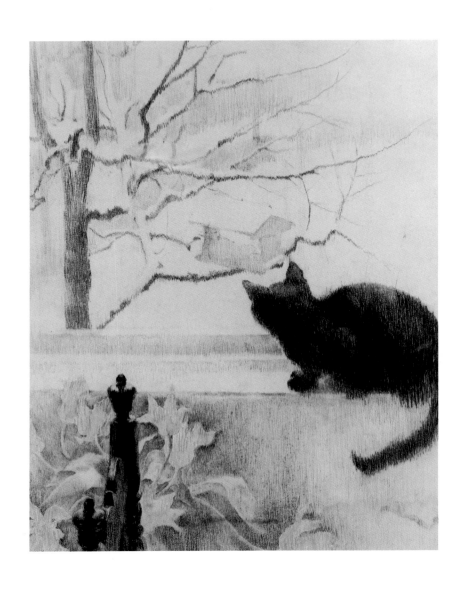

50. *Lilian Westcott Hale, American, 1881–1963*

BLIGHTED HOPE

Charcoal and crayon on paper, 28¾ × 23¾ inches
Collection of Mr. and Mrs. Peter Heydon, Ann Arbor, Michigan

51. *John Sloan, American, 1871–1951*

DOCK STREET MARKET, *ca. 1902*

Oil on canvas, 24 × 36 inches
Montgomery Museum of Fine Arts, Montgomery, Alabama, Montgomery Museum of Fine Arts Association Purchase

52. *John Sloan, American, 1871—1951*

SNOWSTORM IN THE VILLAGE, *1925*

Etching, 7 × 5 inches
Bowdoin College Museum of Art, Brunswick, Maine

53. *George Bellows, American, 1882–1925*

NORTH RIVER, *1908*

Oil on canvas, 32¾ × 42¾ inches
The Pennsylvania Academy of the Fine Arts, Temple Fund Purchase

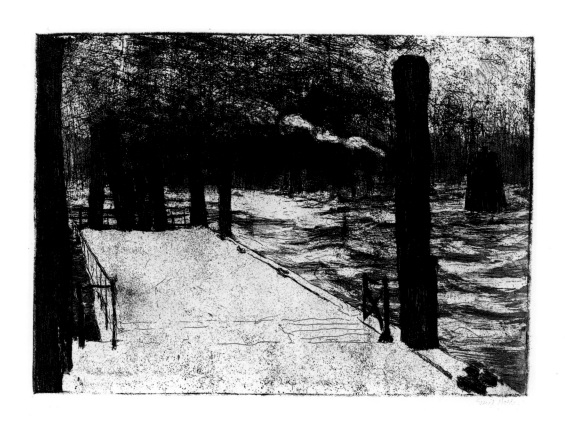

54. *Emil Hansen Nolde, German, 1867–1956*

LANDING PIER, HAMBURG, *1910*

Etching and aquatint, 12 × 15¹⁵⁄₁₆ inches
The Detroit Institute of Arts, City of Detroit Purchase

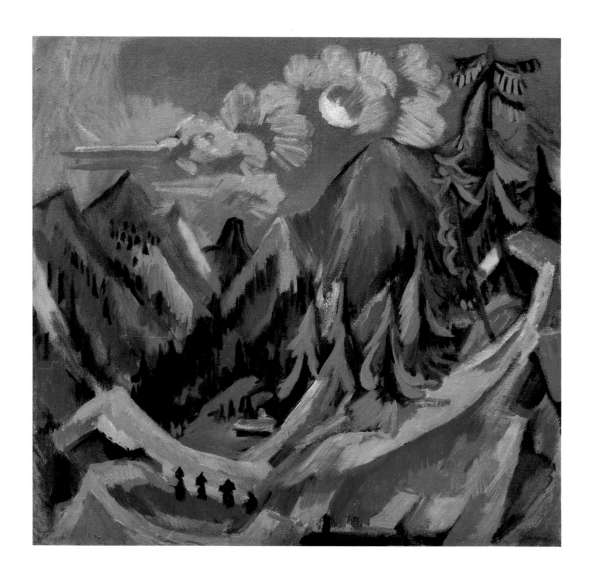

55. *Ernst Ludwig Kirchner, German, 1880–1938*

WINTER LANDSCAPE IN MOONLIGHT, *1919*

Oil on canvas, 47½ × 47½ inches
The Detroit Institute of Arts, Gift of Curt Valentin in memory of the artist

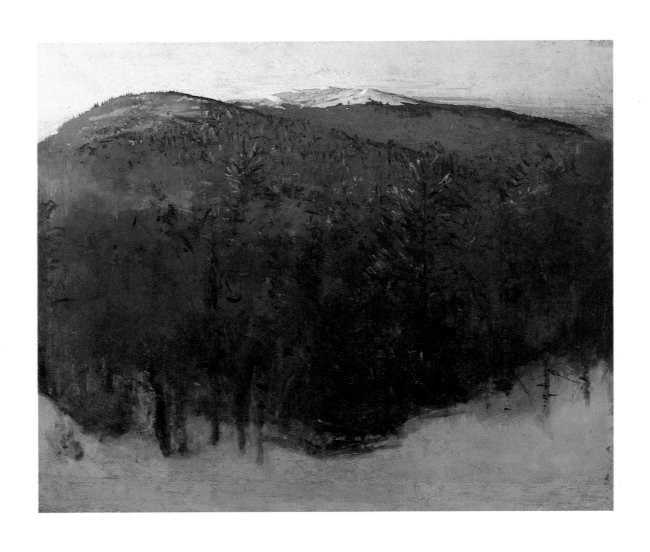

56. *Abbott Handerson Thayer, American, 1849–1921*

SUNRISE ON MOUNT MONADNOCK, NEW HAMPSHIRE, *1919*

Oil on canvas, 52⅜ × 62³⁄₁₆ inches
The Art Museum, Princeton University, Gift of Frank Jewett Mather, Jr.

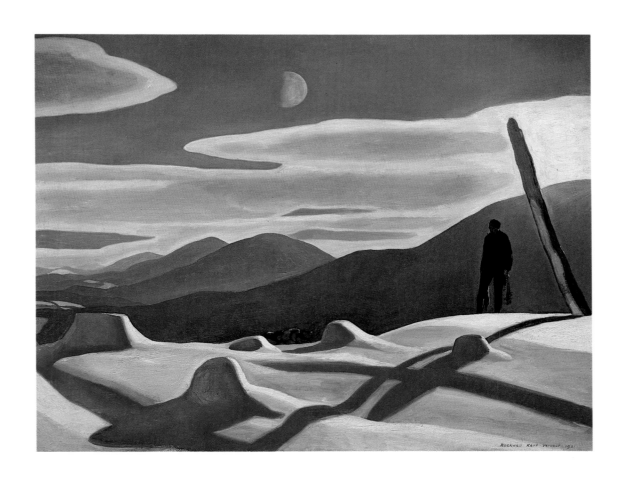

57. *Rockwell Kent, American, 1882–1971*

THE TRAPPER, *1921*

Oil on canvas, 34 × 44 inches
Whitney Museum of American Art, New York, Purchase, 1931, 31.258

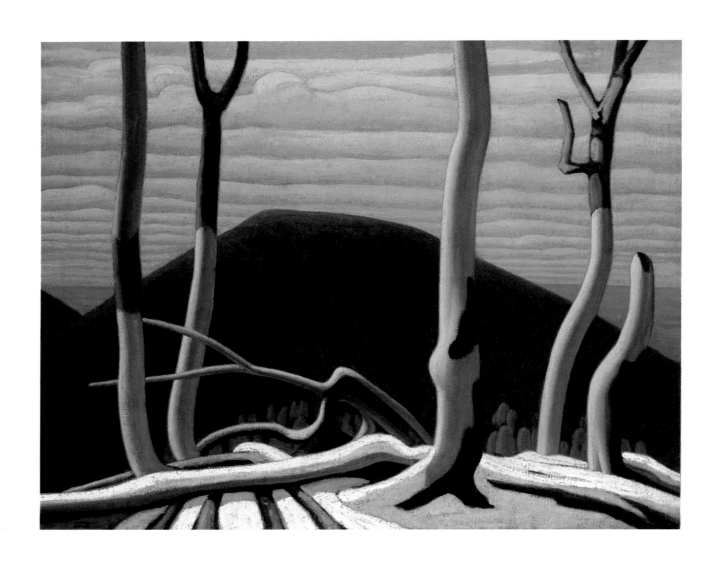

58. *Lawren Harris, Canadian, 1885–1970*

ABOVE LAKE SUPERIOR, *ca. 1922*

Oil on canvas, 48 × 60 inches
Art Gallery of Ontario, Gift from the Reuben and Kate Leonard Memorial Fund, 1929

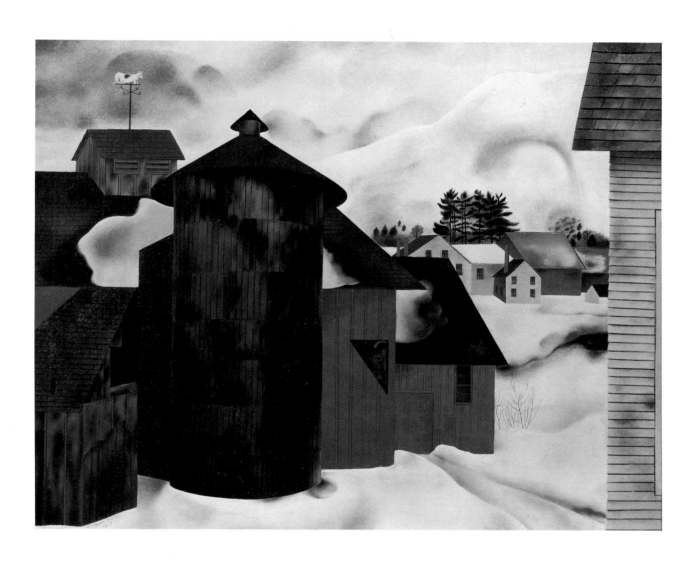

59. *Peter Blume, American, born Russia 1906*

WINTER, NEW HAMPSHIRE, *1927*

Oil on canvas, 20¼ × 25 inches
Museum of Fine Arts, Boston, Bequest of John T. Spaulding

60. *Arthur Dove, American, 1880—1946*

SNOW AND WATER, *1928*

Oil on aluminum, 20 × 27½ inches
The Currier Gallery of Art, Gift of Paul and Hazel Strand

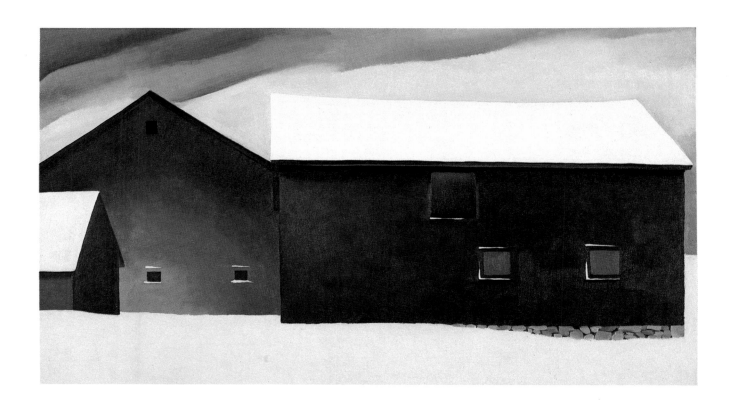

61. *Georgia O'Keeffe, American, born 1887*

BARN WITH SNOW, *1933*

Oil on canvas, 16 × 28 inches
San Diego Museum of Art, Gift of Mr. and Mrs. Norton S. Walbridge

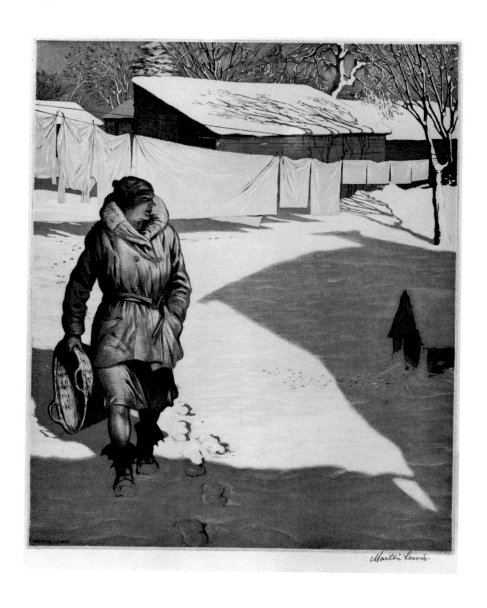

62. *Martin Lewis, American, 1883–1962*

WHITE MONDAY, *1932*

Aquatint and drypoint, 9⅞ × 7⅞ inches
Collection of Mr. and Mrs. Norman Kraeft

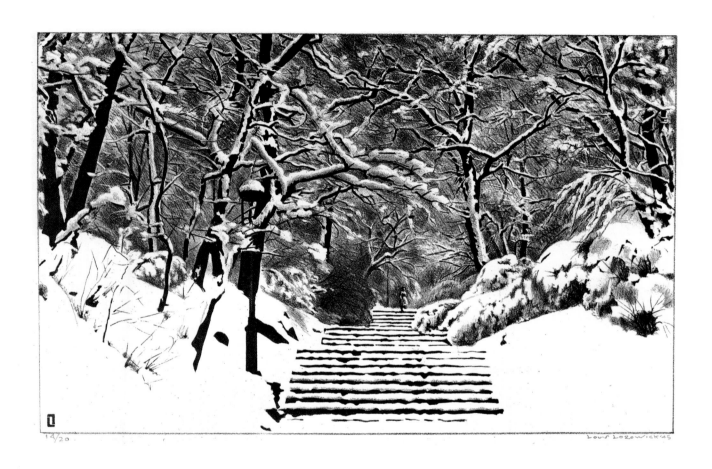

63. *Louis Lozowick, American, 1892–1973*

WHITE MANSIONS, *1945*

Lithograph, 8³⁄₁₆ × 12½ inches
Collection of William S. Clark, Dartmouth College Class of 1942

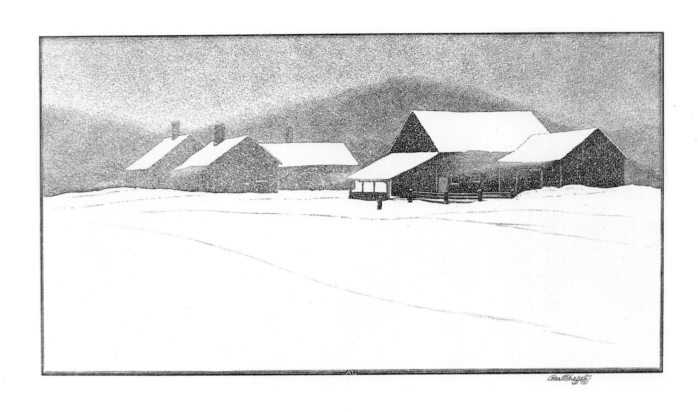

64. *Asa Cheffetz, American, 1897–1965*

WINTER WEATHER, *1949*

Wood engraving, 5 × 8¾ inches
Collection of William S. Clark, Dartmouth College Class of 1942

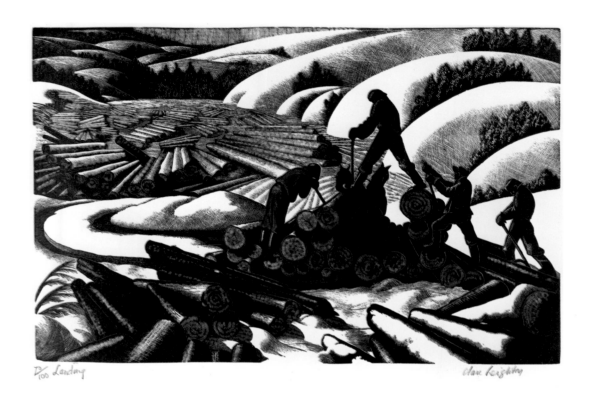

$\frac{D}{100}$ Landing Clare Leighton

65. *Clare Leighton, American, born 1901*

LANDING

Wood engraving, 8¼ × 12½ inches
Collection of William S. Clark, Dartmouth College Class of 1942

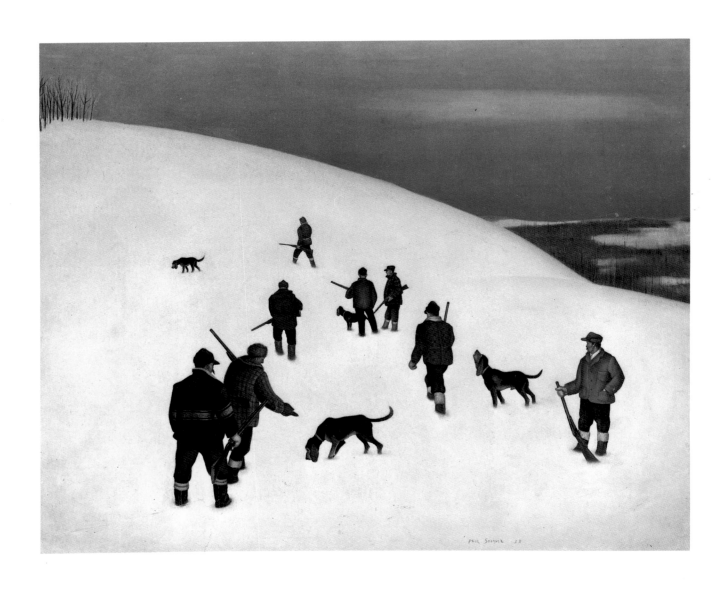

66. *Paul Sample, American, 1896–1974*

LAMENTATIONS V:18 (FOX HUNT), *1938*

Oil on canvas, 30 × 36 inches
Addison Gallery of American Art, Phillips Academy, Andover, Massachusetts, Gift of Milton Lowenthal

67. *Grant Wood, American, 1892–1942*

JANUARY, *1940*

Oil on masonite, 18 × 24 inches
Collection of King W. Vidor Trust

68. *George Ault, American, 1891−1948*

JANUARY FULL MOON, *1941*

Oil on canvas, 20 × 26 inches
Collection of Raymond J. Learsy

69. *Charles Burchfield, American, 1893–1967*

SNOWSTORM ON SWEET ROAD, *1947*

Watercolor, 28 × 40 inches
Collection of Raymond J. Learsy

70. *Charles Burchfield, American, 1893–1967*

MARCH WIND, *1951*

Watercolor, 30 × 40 inches
Collection of Mr. and Mrs. John I. H. Baur

71. *Neil Welliver, American, born 1929*

WINTER STREAM, *1976*

Oil on canvas, 95⅞ × 96 inches
Smith College Museum of Art, Northampton, Massachusetts, Gift of Mrs. Leonard S. Mudge in memory of
Polly Mudge Welliver ('60), 1978

72. *Peter Milton, American, born 1930*

SANCTUARY'S EDGE, *1981*

Lift-ground etching and engraving, 47⅞ × 31¾ inches
Hood Museum of Art, Dartmouth College, Gift of John L. Ames, Jr., Class of 1916

73. *Wolf Kahn, American, born 1927*

WINTER IN THE UPPER VALLEY, *1984*

Oil on canvas, 36 × 52 inches
Collection of Mr. and Mrs. A. L. Aydelott

74. *Richard Bosman, Australian, born 1944*

THE HUNTERS, *1984*

Oil on canvas, 72 × 108 inches
Collection of Raymond J. Learsy

75. *Alfred Stieglitz, American, 1864–1946*

THE STREET—DESIGN FOR A POSTER, *published in* CAMERA WORK,
 No. 3, July, 1903

Photogravure, 7 × 5¼ inches
Dartmouth College Library

76. *Alfred Stieglitz, American, 1864–1946*
THE FLATIRON BUILDING, 1902?

Photogravure, 13 × 6½ inches
Gilman Paper Company Collection

77. *Alfred Stieglitz, American, 1864–1946*

ICY NIGHT, *1898*

Photogravure, 4⅞ × 6¹/₁₆ inches
Hood Museum of Art, Dartmouth College, Extended loan

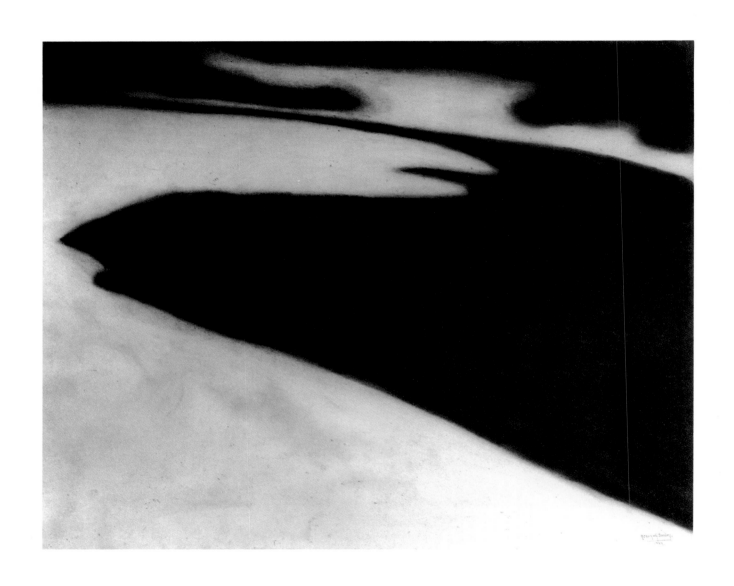

78. *George Seeley, American, 1880–1955*

WINTER LANDSCAPE, *1909*

Gum bichromate and platinum print, 17¼ × 21¼ inches
Gilman Paper Company Collection

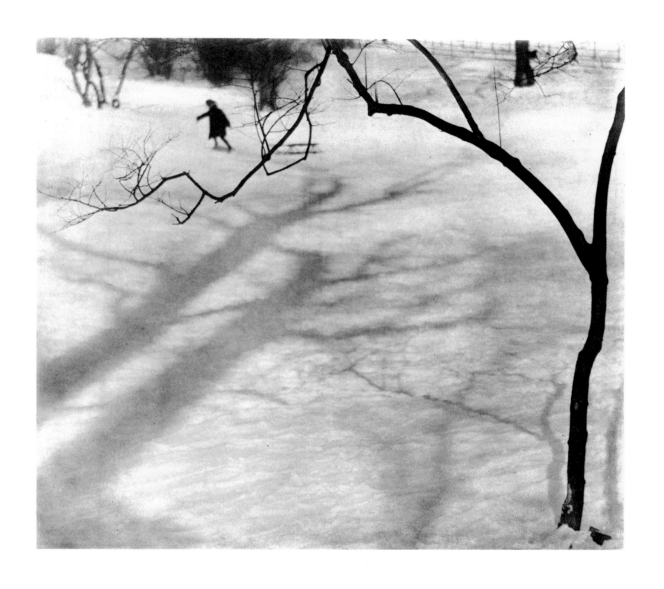

79. *Paul Strand, American, 1864–1976*

WINTER, CENTRAL PARK, NEW YORK, *ca. 1915*

Platinum print, 10 × 11 inches
Gilman Paper Company Collection

80. *Lazlo Moholy-Nagy, American, born Hungary, 1895–1946*

FROM THE RADIO TOWER, BERLIN, *1928*

Silver print, 10 × 7¾ inches
Gilman Paper Company Collection

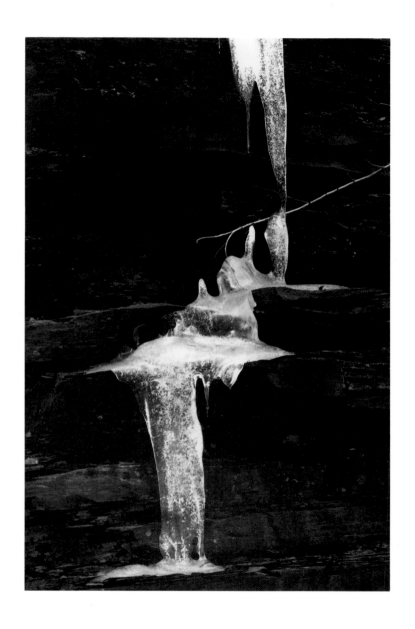

81. *Minor White, American, 1908–1976*

WATKINS GLEN, NEW YORK, *1963*

Silver print, 9⅛ × 5⅞ inches

Hood Museum of Art, Dartmouth College, Extended loan. Reproduction courtesy of the Minor White Archive, Princeton University.

 Copyright © 1985 The Trustees of Princeton University

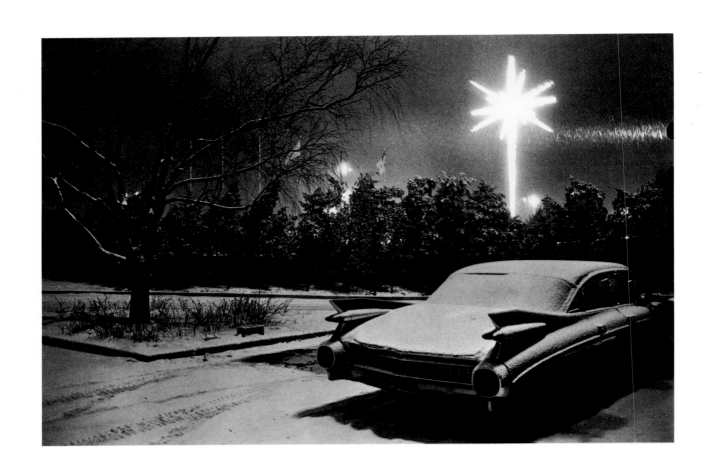

82. *Joel Meyerowitz, American, born 1938*

CHRISTMAS, KENNEDY AIRPORT, *1967*

Gelatin-silver print, 9 × 13½ inches
The Museum of Modern Art, New York, Purchase

The description reads as follows:

Location Piece #5
Massachusetts – New Hampshire
On February 7, ten photographs were made of snow
lying 12 feet from the edge of Interstate Highway 495 in both
Massachusetts and New Hampshire.

Each photograph was made at an interval of every
5 miles; or of every 5 yards; or of every 5 feet; or of a variable
combination of all of those intervals.

Ten photographs and this statement constitute the form
of this piece.

February, 1969

83. *Douglas Huebler, American, born 1924*

LOCATION PIECE #5 MASSACHUSETTS–NEW HAMPSHIRE, *1969*

Ten silver prints, each 9¼ × 7¼ inches
Gilman Paper Company Collection

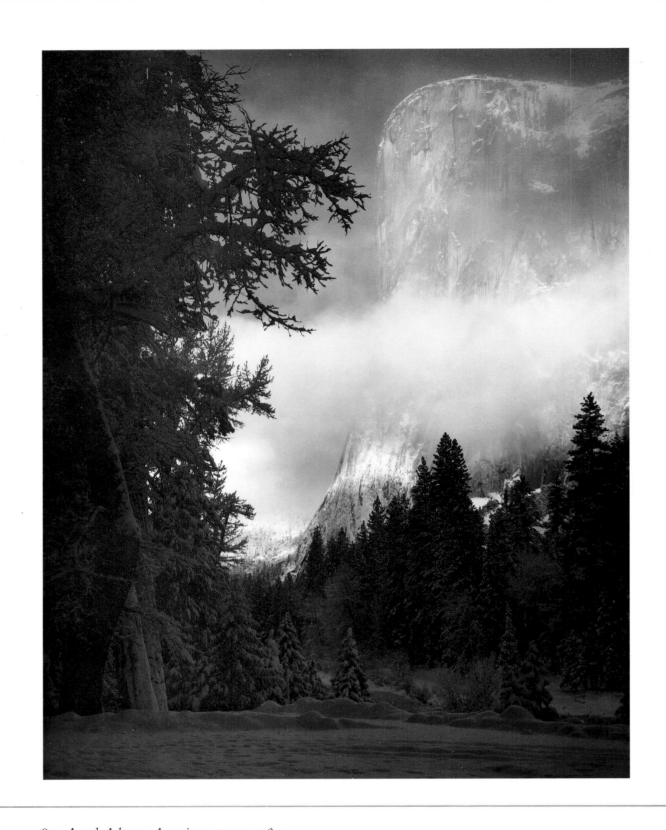

84. *Ansel Adams, American, 1902–1984*

EL CAPITAN, SUNRISE, WINTER, YOSEMITE VALLEY, CALIFORNIA, *ca. 1968,*
from PORTFOLIO VII, *1976*

Silver print, 19¼ × 15⅜ inches
Hood Museum of Art, Dartmouth College, Extended loan. Reproduction courtesy of the Ansel Adams
Publishing Rights Trust. All rights reserved

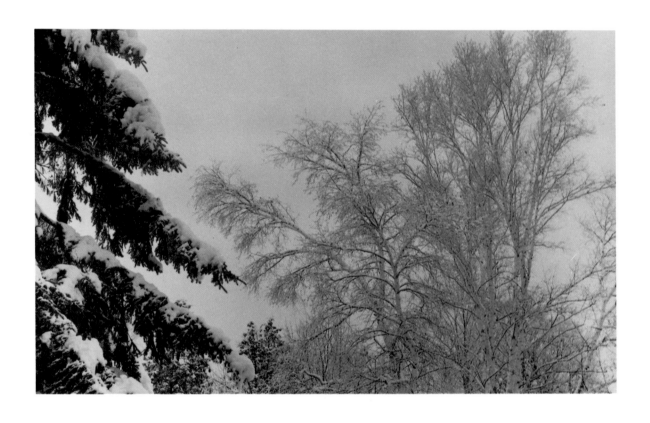

85. *Ralph Steiner, American, born 1899*

UNTITLED, *ca. 1970*

Silver print, 4¼ × 6½ inches
Collection of Ralph Steiner, Dartmouth College Class of 1921

PHOTO CREDITS

Numbers refer to catalogue numbers.
Breger & Associates: 24
Geoffrey Clements: 57, 70
Roy M. Elkind: 68, 69
Colin McRae: 32
Otto E. Nelson: 6–8
Jeffrey Nintzel: 4, 10, 11, 17, 19, 21, 22, 27, 28,
 37, 38, 39, 62, 72, 75, 77, 81, 85
Ken Pokorny: 35, 50
Scott Photographic Services: 51
Ivan Dalla Tana: 74
Frank Ward: 16
Sarah Wells: 73

INDEX OF ARTISTS

Adams, Ansel, 132; *El Capitan, Sunrise, Winter, Yosemite Valley, California*, 132 (illus.)

Ault, George, 116; *January Full Moon*, 116 (illus.)

Avercamp, Hendrick, 28, 29, 35; *Winter Scene on a Canal*, 29 (illus.)

Bellows, George, 101; *North River*, 101 (illus.)

Bierstadt, Albert, 80; *Yosemite Winter Scene*, 80 (illus.)

Blume, Peter, 107; *Winter, New Hampshire*, 107 (illus.)

Bosman, Richard, 122; *The Hunters*, 122 (illus.)

Boucher, François, 36

Bruegel, Pieter the Elder, 17, 20–23, 24, 28–30, 32, 33, 35–36, 42, 44–45; *The Adoration of the Magi in the Snow*, 35 (illus.), 36, 42, 45; *The Return from the Hunt*, 22, 23 (illus.), 24, 33; *The Skaters (The Bird Trap)*, 28. *See also* Bruegel, Pieter the Elder, School of, *and* Huys, Frans

Bruegel, Pieter the Elder, School of, 28, 63; *Landscape with Bird Trap*, 28, 63 (illus.)

Buhot, Félix-Hilaire, 85; *Winter in Paris* or *Paris in the Snow*, 85 (illus.)

Burchfield, Charles, 44, 117, 118; *March Wind*, 44, 118 (illus.); *Snowstorm on Sweet Road*, 117 (illus.)

Cheffetz, Asa, 112; *Winter Weather*, 112 (illus.)

Church, Frederic Edwin, 79; *Winter Landscape from Olana*, 79 (illus.)

Cropsey, Jasper Francis, 33, 39, 74; *Winter Landscape, North Conway, N.H.*, 33, 39, 74 (illus.)

Currier and Ives, 39

Darley, Felix Octavius Carr, 76. *See also* Lafosse, Jean-Baptiste-Adolphe

Detaille, Jean-Baptiste-Edouard, 40, 84; *The Retreat* or *French Artillery*, 40, 84 (illus.)

Dove, Arthur, 108; *Snow and Water*, 108 (illus.)

Dürer, Albrecht, 16

Durrie, George Henry, 33, 39, 42, 73, 75; *Gathering Wood for Winter*, 39, 42, 73 (illus.); *Skating on the Connecticut River*, 30, 75 (illus.)

Eyck, Jan van, 16

Friedrich, Caspar David, 40, 43; *Cloister Graveyard in the Snow*, 40, 43 (illus.)

Gerrytsz, Hessel, 65; *Winter*, 30, 65 (illus.)

Gignoux, Régis François, 33, 72; *Winter Scene*, 33, 72 (illus.)

Goes, Hugo van der, 32

Gogh, Vincent van, 91, 92; *Garden of the Rectory at Nuenen*, 92 (illus.); *Road near Nuenen*, 91 (illus.)

Goltzius, Hendrik, 64. *See also* Saenredam, Jan

Goya, Francisco, 24; *La Nevada (The Snow Storm)*, 27 (illus.)

Grimshaw, Arthur E., 83; *A Winter Lane*, 83 (illus.)

Gros, Baron Antoine Jean, 40; *Battle of Eylau*, 40

Hale, Lilian Westcott, 98; *Blighted Hope*, 98

Halsall, William Formby, 81; *Summit of Mount Washington in Winter*, 81 (illus.)

Harris, Lawren, 33, 106; *Above Lake Superior*, 33, 106 (illus.)

Hassam, Childe, 38–39, 95; *Late Afternoon, New York: Winter*, 38, 95 (illus.), cover (illus.)

Hills, Robert, 36, 68; *A Village Snow Scene*, 36, 68 (illus.)

Homer, Winslow, 82; *Sleigh Ride*, 82 (illus.)

Houdon, Jean-Antoine, 18, 19, 20; *La Frileuse (Winter)*, 18, 19 (illus.), 20

Huebler, Douglas, 131; *Location Piece #5 Massachusetts-New Hampshire*, 131 (illus.)

Huys, Frans, 62; *Skaters Before the Gate of St. George in Antwerp*, 29, 62 (illus.)

Inness, George, 78; *Christmas Eve*, 78

Johnson, Eastman, 42, 77; *Sugaring Off*, 42, 77 (illus.)

Jongkind, Jean-Barthold, 87; *Winter Scene*, 87 (illus.)

Kahn, Wolf, 121; *Winter in the Upper Valley*, 121 (illus.)

Kent, Rockwell, 24, 33, 105; *The Trapper*, 24, 33, 105 (illus.)

Kirchner, Ernst Ludwig, 103; *Winter Landscape in Moonlight*, 103 (illus.)

Lafosse, Jean-Baptiste-Adolphe, 76; *Winter*, 76 (illus.)

Lawson, Ernest, 42, 97; *Spring Thaw*, 42, 97 (illus.)

Leighton, Clare, 113; *Landing*, 113

Lepère, Louis-Auguste, 86; *Paris in the Snow, Morning of March 1, 1890, from the Tower of Saint-Gervais*, 86 (illus.)

Lewis, Martin, 110; *White Monday*, 110 (illus.)

Li Cheng (Li Ch'eng), 44

Limbourg Brothers, 20, 21, 32; *December*, 24, 25 (illus.); *February*, 20, 21 (illus.); *Les Très Riches Heures du Duc de Berry*, 20, 21, 22, 24, 26, 32

Limbourg, Pol, 32

Lozowick, Louis, 111; *White Mansions*, 111 (illus.)

Matsumura Goshun (Gekkei), 44, 53; *The Road to Shu*, 44, 53 (illus.)

Meissonier, Jean-Louis-Ernest, 40

Metcalf, Willard L., 36, 96; *The White Veil*, 36, 96 (illus.)

Meyerowitz, Joel, 130; *Christmas, Kennedy Airport*, 130 (illus.)

Milton, Peter, 120; *Sanctuary's Edge*, 120 (illus.)

Moholy-Nagy, Lazlo, 128; *From the Radio Tower, Berlin*, 128 (illus.)

Molijn, Pieter, 66; *Winter Landscape*, 66 (illus.)

Monet, Claude, 38, 42, 44, 89, 90; *The Floating Ice*, 38, 42, 89 (illus.); *Haystacks in the Snow*, 38, 90 (illus.)

Morland, George, 67; *Winter Landscape*, 67 (illus.)

Mount, William Sidney, 24, 71; *Catching Rabbits (Boys Trapping)*, 24, 71

Nolde, Emil Hansen, 102; *Landing Pier, Hamburg*, 102 (illus.)

O'Keeffe, Georgia, 109; *Barn with Snow*, 109 (illus.)

Pissarro, Camille, 38, 45, 88; *Piette's House at Montfoucault (Snow)*, 38, 45, 88 (illus.)

Poussin, Nicolas, 36; *Deluge*, 36; *Four Seasons*, 36

Prior, William Matthew, 70; *In with the Sleigh*, 70 (illus.) (attribution)

Remington, Frederic, 40, 41; *Battle of War Bonnet Creek*, 40, 41 (illus.)

Ruisdael, Jacob van, 33, 34, 35; *Winter Landscape with a Windmill*, 34 (illus.), 35

Saenredam, Jan, 64; *Winter*, 26, 64 (illus.)

Sample, Paul, 114; *Lamentations V: 18 (Fox Hunt)*, 114 (illus.)

Seeley, George, 126; *Winter Landscape*, 126 (illus.)

Shen Zhou (Shen Chou), 44, 49; *Snow Scene*, 49 (illus.)

Shoson Ohara-Matao, 60; *Nanten Bush and Fly Catchers in the Snow*, 60 (illus.)

Signac, Paul, 36, 38, 93; *Boulevard de Clichy*, 36, 38, 93 (illus.)

Sisley, Alfred, 38

Sloan, John, 99, 100; *Dock Street Market*, 99 (illus.); *Snowstorm in the Village*, 100 (illus.)

Steiner, Ralph, 33, 133; *Untitled*, 133 (illus.)

Stieglitz, Alfred, 123, 124, 125; *The Flatiron Building*, 124 (illus.); *Icy Night*, 125 (illus.); *The Street—Design for a Poster*, 123 (illus.)

Strand, Paul, 127; *Winter, Central Park, New York*, 127 (illus.)

Stuart, Gilbert, 30–32; *The Skater (Portrait of William Grant)*, 30, 31 (illus.), 32

Sully, Thomas, 69; *Skater*, 30, 69 (illus.)

Thayer, Abbott Handerson, 104; *Sunrise on Mount Monadnock, New Hampshire*, 104 (illus.)

Turner, Joseph Mallord William, 36, 37, 38; *Valley of Aosta—Snowstorm, Avalanche and Thunderstorm*, 36, 37 (illus.)

Twachtman, John Henry, 33, 42, 94; *End of Winter*, 42, 94 (illus.)

Unknown, Chinese: *Nine Egrets in a Snowy Landscape*, 52 (illus.)

Unknown, Dutch: *Untitled (Ludwina Falling on Ice)*, 26, 28, 61

Unknown, Roman: *Front of a Child's Season Sarcophagus of the Asiatic Columnar Type*, 20, 22 (illus.)

Utagawa (Andō) Hiroshige, 58, 59; *Hodogaya*, 59 (illus.); *Kambara, Night Snow*, 58 (illus.)

Utagawa Kuniyoshi, 45, 57; *Black Turban*, 45, 57 (illus.)

Van der Neer, Aert, 28, 33

Vinckboons, David, 65. *See also* Gerrytsz, Hessel

Wang Hui, 51; *Winter Scene*, 51 (illus.)

Welliver, Neil, 119; *Winter Stream*, 119 (illus.)

Wen Zhengming (Wen Cheng-ming), 44, 50; *Snow Scene*, 50 (illus.)

White, Minor, 129; *Watkins Glen, New York*, 129 (illus.)

Wood, Grant, 42, 115; *January*, 42, 115 (illus.)

Yokoi Kinkoku, 45, 54, 55, 56; *Winter Landscape*, 54 (illus.); *Winter Landscape*, 55 (illus.); *Winter Landscape*, 56 (illus.)

Yosa Buson, 44. *See also* Yosa Buson, School of; Matsumura Goshun (Gekkei); *and* Yokoi Kinkoku

Yosa Buson, School of, 44, 45